D1377274

Snail MAIL my email

HANDWRITTEN LETTERS in a DIGITAL WORLD

IVAN CASH

LIBRARY
NSCC, KINGSTEC CAMPUS
236 BELCHER ST.
WITHDRAWN
KENTVILLE, NS B4N 0A6 CANADA

sourcebooks

Copyright © 2012 by Ivan Cash
Cover and internal design © 2012 by Sourcebooks, Inc.
Cover design by Laura Palese
Cover illustrations by Chris Piascik
Internal design by Ivan Cash

Sourcebooks and the colophon are registered trademarks of Sourcebooks, Inc.

All rights reserved. No part of this book may be reproduced in any form or by any electronic or mechanical means including information storage and retrieval systems—except in the case of brief quotations embodied in critical articles or reviews—without permission in writing from its publisher, Sourcebooks, Inc.

This publication is designed to provide accurate and authoritative information in regard to the subject matter covered. It is sold with the understanding that the publisher is not engaged in rendering legal, accounting, or other professional service. If legal advice or other expert assistance is required, the services of a competent professional person should be sought.—*From a Declaration of Principles Jointly Adopted by a Committee of the American Bar Association and a Committee of Publishers and Associations*

All brand names and product names used in this book are trademarks, registered trademarks, or trade names of their respective holders. Sourcebooks, Inc., is not associated with any product or vendor in this book.

Published by Sourcebooks, Inc.
P.O. Box 4410, Naperville, Illinois 60567-4410
(630) 961-3900
Fax: (630) 961-2168
www.sourcebooks.com

Library of Congress Cataloging-in-Publication Data

Cash, Ivan.
 Snail mail my email : handwritten letters in a digital world / Ivan Cash.
 pages cm
 1. Cash, Ivan—Themes, motives. 2. Group work in art. 3. Electronic mail messages—Miscellanea. 4. Letter writing—Miscellanea. I. Cash, Ivan. Works. Selections. II. Title.
 N6537.C348A4 2012
 709.04'084—dc23
 2012027040

Printed and bound in the United States of America.
BG 10 9 8 7 6 5 4 3 2 1

10 YEARS AGO

Ding!!! You've got mail!!!

NOW

436 unread emails

poofytoo.tumblr.com

DEDICATION

This book is dedicated to the many "strangers" who spontaneously came together and collectively devoted their time, energy, and resources to a commerce-free, passion-based project, allowing it to take on an otherwise impossible global scale.

A portion of the author's proceeds has been donated on behalf of these generous volunteers to Room to Read, a nonprofit organization focused on educating children worldwide.

INTRODUCTION

In July of 2011, I quit (what I thought was) my dream job at an advertising agency and set off in search of a more balanced lifestyle. I promised myself to live more mindfully and engage in slower activities. One such activity, letter writing, was always a passion of mine but had been neglected while working full time in the corporate world.

Compared to the instant gratification clicking "send" on an email provides, there's something deeper about communicating in the intentional, slow-paced, and tangible form that—in the age of Internet communication—is widely referred to as "snail mail."

And so, two weeks after leaving my job, I created Snail Mail My Email, a month-long online art project where I aimed to send handwritten letters to as many people as possible while building excitement about letter writing in the process. The project's website offered these simple instructions:

Type a message to a friend, family member, pet, politician, or lover, and email it to snailmailmyemail@gmail.com. Then sit back and relax while your email is handwritten, sent out, and delivered to the recipient of your choosing, completely free of charge!

Letter requests could include custom options like a doodle, flower petal, or lipstick kiss, if so desired.

The nostalgia for letter writing apparently hit an emotional nerve, as more than one thousand letter requests poured in on the project's fourth day alone. Despite family and friends lending a hand, this demand was insurmountable. I was begrudgingly forced to halt the project and reevaluate its scope.

Later that day, Lucy, a recent NYU grad living in Shanghai reached out to offer her services as a volunteer letter writer. Similar offers began trickling in, and the idea of crowdsourcing a team of volunteer letter writers appeared to be a viable way of continuing forward. I posted a call to arms on the project's website and was completely floored when people whom I've never met responded with such enthusiasm, eager to help out.

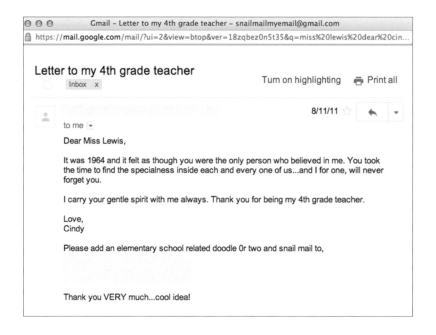

Letter to my 4th grade teacher

Inbox x

Turn on highlighting Print all

8/11/11

to me

Dear Miss Lewis,

It was 1964 and it felt as though you were the only person who believed in me. You took the time to find the specialness inside each and every one of us...and I for one, will never forget you.

I carry your gentle spirit with me always. Thank you for being my 4th grade teacher.

Love,
Cindy

Please add an elementary school related doodle 0r two and snail mail to,

Thank you VERY much...cool idea!

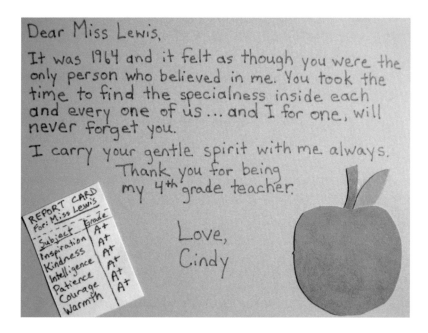

Dear Miss Lewis,

It was 1964 and it felt as though you were the only person who believed in me. You took the time to find the specialness inside each and every one of us... and I for one, will never forget you.

I carry your gentle spirit with me always. Thank you for being my 4th grade teacher.

Love,
Cindy

REPORT CARD
For: Miss Lewis

Subject	Grade
Inspiration	A+
Kindness	A+
Intelligence	A+
Patience	A+
Courage	A+
Warmth	A+

Original Email Letter Request *(top)* / Letter Artist: Jessica Franken, Minnesota to New Hampshire *(bottom)*

INTRODUCTION CONT.

Lucy immediately stepped up as Project Manager while Terry, an Oklahoma City-based musician, joined as Administrator. We worked furiously and, after a few sleepless nights, developed a company-esque structure, making it possible to manage an international team that grew to become 234 people strong. The generosity and participation of these dedicated volunteers allowed the project to take on a large scale.

After the month was up, 10,457 handwritten letters had been sent out (with postage covered by the volunteers) to more than 70 countries, spanning across all seven continents. These "letter artists" were asked to document their work and the letter's route before mailing, resulting in an archive from which this book's selections are comprised.

I think so many people responded to this project because, despite living in an era increasingly dominated by technology, we as human beings still crave tangible, intimate connections...even if it's a stranger providing these experiences for us. With that said, I hope you find the letters within this book as entertaining, heartfelt, bizarre, honest, endearing, unexpected, creative, and inspiring as I did.

Ultimately, there are many ways to find more human connections within our technology-laden lives. Some may choose, as I did, to walk away from their jobs, but walking to a mailbox might work just as well.

Now go send a letter!

Ivan Cash
Creator of Snail Mail My Email

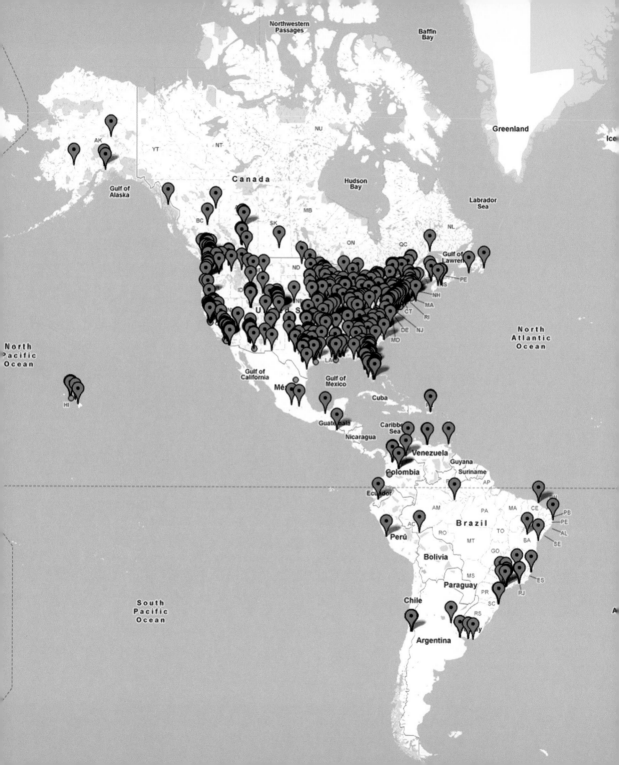

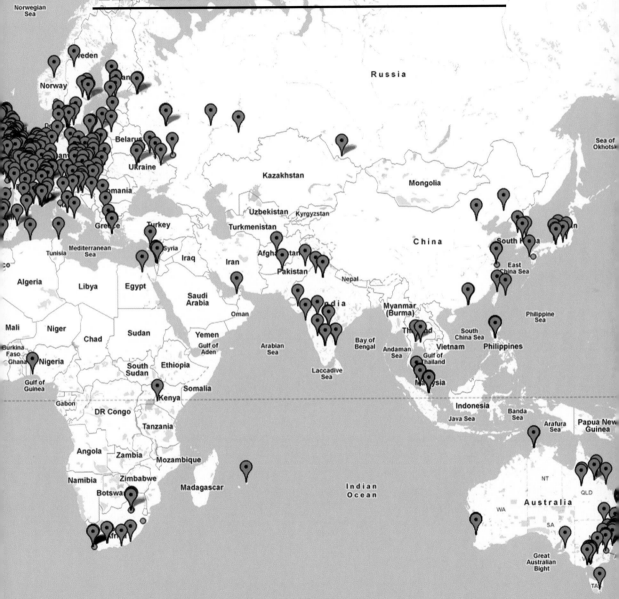

LETTERS SENT AROUND THE WORLD

Snail Mail – snailmailmyemail@gmail.com – Gmail

https://mail.google.com/mail/u/2/?ui=2&view=btop&ver=18zqbez0n5t35&q=bethany%20wonderful&qs=true&search=quer...

Snail Mail

Inbox x

Turn on highlighting 🖨 Print all

Tammy 8/6/11 ☆ ↩ ▾

to me ▾

Please take complete creative freedom in writing my letter. Thank you so much!

Recipient:

Bethany,
I know you had a wonderful summer and I can't wait to see you so that you can tell
me all about it! I hope you're not having troubles with getting settled in at school.
Good luck with athletic training and I'll see you when I get to Bridgewater! I miss you!

xoxo, Tammy

Click here to Reply or Forward

Original Email Letter Request

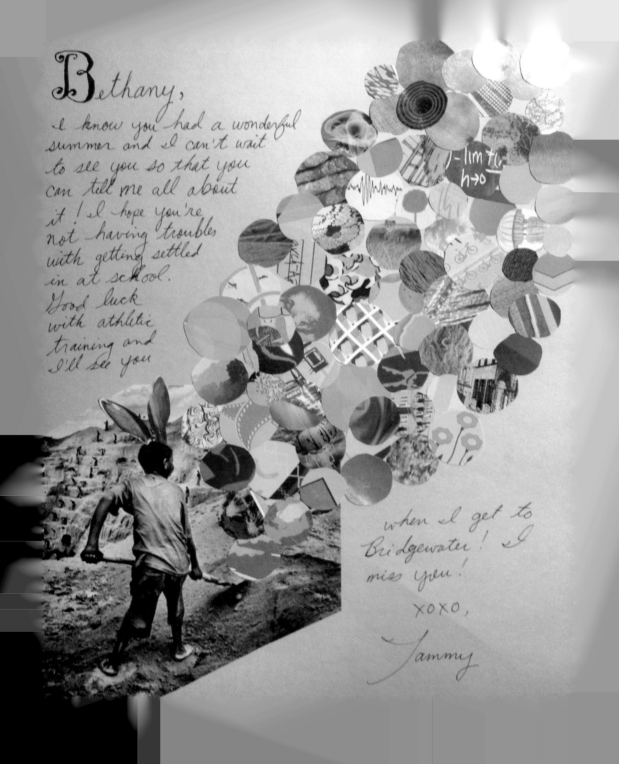

Bethany,

I know you had a wonderful summer and I can't wait to see you so that you can tell me all about it! I hope you're not having troubles with getting settled in at school. Good luck with athletic training and I'll see you

when I get to Bridgewater! I miss you!

XOXO,

Tammy

Original Email Letter Request

Andy,
While you're hard at work,
I am at home making
blueberry pancakes
while naked.

— S

Letter Artist: Beth Schmidt, Pennsylvania to Canada

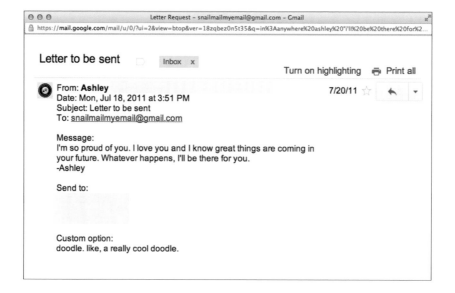

Original Email Letter Request

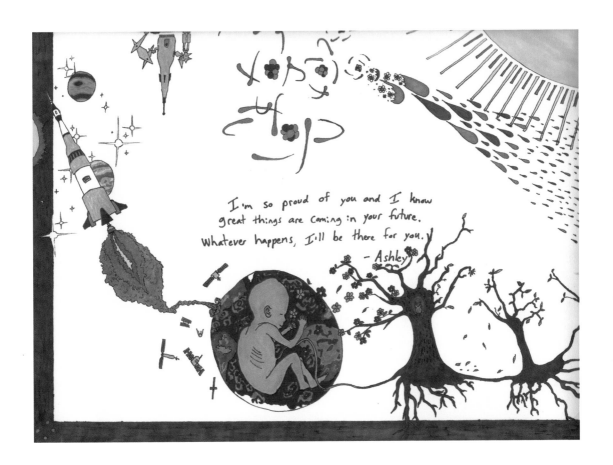

I'm so proud of you and I know great things are coming in your future. Whatever happens, I'll be there for you.
– Ashley

Letter Artist: Chris Boyce, New York to Illinois

Letter Artist: Katherine Rasmussen, California to New York

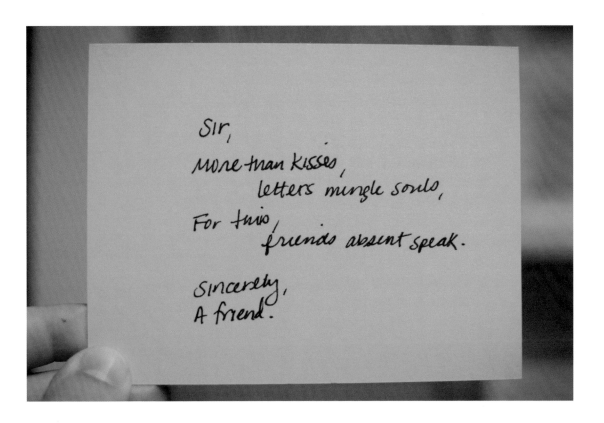

Sir,
more than kisses,
 letters mingle souls,
For this,
 friends absent speak.

Sincerely,
A friend.

Letter Artist: Laura Wiesner, Minnesota to Austria

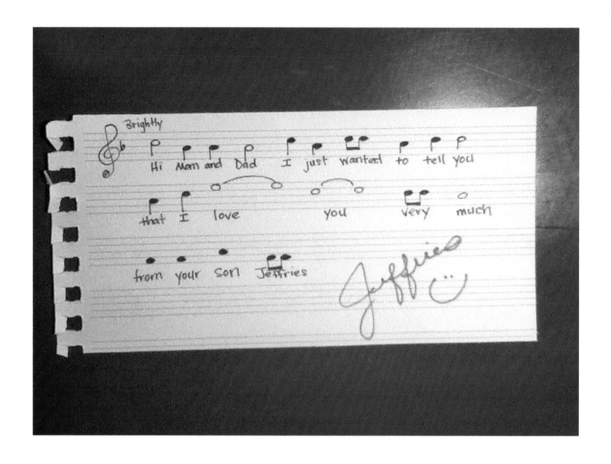

Letter Artist: Beth Schmidt, Pennsylvania to Chile

Dear Thea

You will read this when you are able.

Your mom will read this ahead because she can. You are only eight months old as I write this, and I'm sure by the time you read this, snail mail will be a strange idea. So here's a letter to help you brag to your friends in the future, that when you were just a baby, a mail came for you through the post office. Make sure you tell them it came from me. I love you.

Lots of love,

Your Tito Lem

Letter Artist: Maryam Hamzah, Malaysia to Philippines

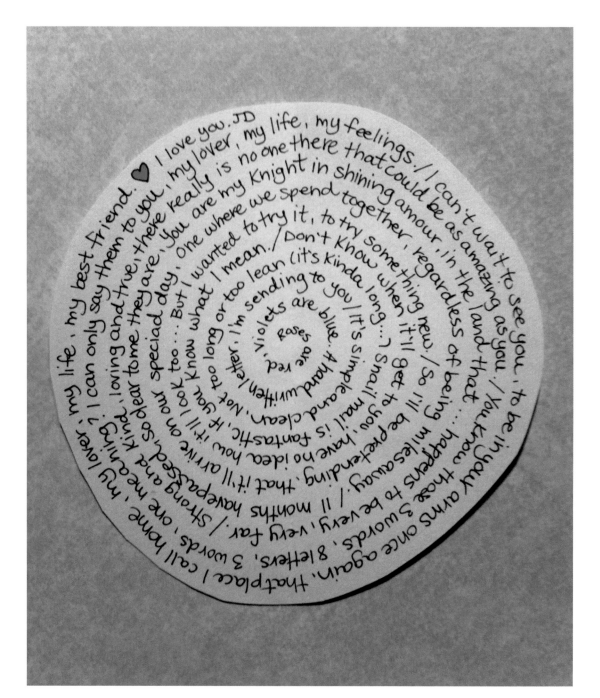

Letter Artist: Sheilla May Cervantes, Pennsylvania to Iowa

August 5, 2011

Dearest Annie,

MAX.
ALWAYS.
WINS.

Don't ever forget that.

Letter Artist: Leah Randall, Georgia to Ohio

Translation from French:

This morning when we went out on our sailfish, we were so close together. You're the man of my life. I can't live without you. My dearest wish is that we marry and have a family. I need you, my dear heart. This morning I got a message that I was able to write. That's rare, rare like you, like us. I love you

Letter Artist: Stefanie Beck, Germany to France

CE MATIN, EN SORTANT DU

SAILFISH, NOUS NOUS

SOMMES ACCROCHÉS.

CE MATIN, TU M'AS ÉCRIT

'TU ES L'HOMMES DE MA VIE.

JE NE PEUX PAS VIVRE SANS

TOI. MON SOUHAIT LE PLUS

CHER, QU'ON SE MARIE ET

QU'ON FONDE NOTRE

FAMILLE. J'AI BESOIN DE

TOI MON COEUR.'

CE MATIN, J'AI REÇU UN

TEXTO QUE J'AURAI PU

ÉCRIRE.

C'EST RARE, RARE COMME

TOI. COMME NOUS.

JE T'AIME

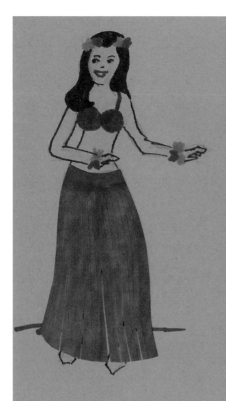

Dear Mom,

You're the best. Thank you for always being supportive of me. Thank you for keeping an open mind and contributing to my own mind expansion. Thank you for teaching me to be independent. Thank you for teaching me the hula. Cheers to more good times ahead.

XOXO Love, Annie

Letter Artist: Charlotte Easterling, Wisconsin to Florida

August 4, 2011

Dear Ms. Dana,

I wanted to apologize for my behaviour. I've never been that frustrated. Although I understand what happened, I know that a man, his fault or not, shouldn't lose control over his words. I understand the position I put you in, while you stood by your daughter's side, seeing her sad over a boy, seeing her lose her own control too, and then, not feeling appreciated by her the very next day. You deserve and have my full appreciation, Ms. Dana, for giving me the chance to get to know her. Thank you so much for that and again, I'm sorry.

Sincerely,
Robin S.

Letter Artist: Jennifer Hanley Knight, California to Pennsylvani

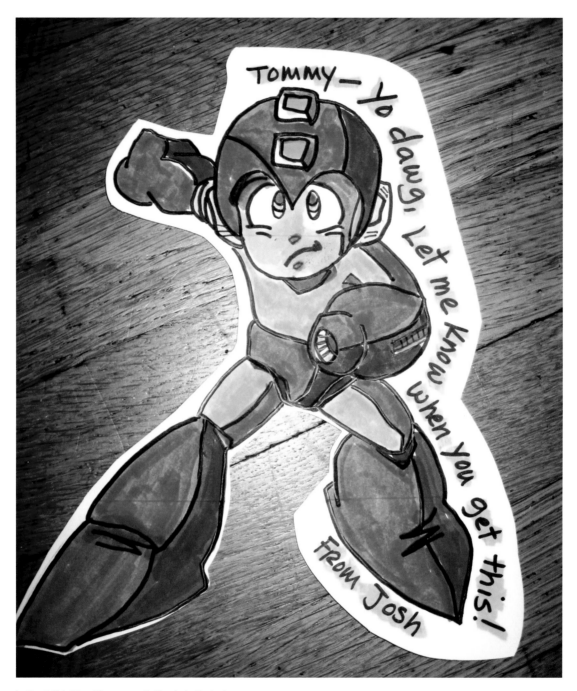

Letter Artist: Mary Thompson, California to Kentucky

Hello Aaron,

This is you from the future.
Yes I know it is mind blowing
but calm down.
Right now in the future town
of Aarontropolis There is a war.
It is a big war against our town's
people and ninjas. Yes I know
your probably saying but future
me ninjas are invisible. Well
yeah they are, but our best
scientists have made goggles
that show the ninjas. So yes the
battle is going great but, we are
kinda getting beaten I better send
this letter before I get killed oh
and the most important Thing you

ne...

Letter Artist: Feras Sobh, United Arab Emirates to Texas

YOUR LIFE IS YOUR LIFE.
DON'T LET IT BE CLUBBED INTO
DANK SUBMISSION
BE ON THE WATCH.

THE GODS WILL OFFER YOU CHANCES

KNOW THEM. TAKE THEM.

YOU CAN'T BEAT DEATH.
BUT YOU CAN BEAT
DEATH IN LIFE,

SOMETIMES.

AND THE MORE OFTEN YOU LEARN TO DO IT,
THE MORE LIGHT THERE WILL BE.

YOUR LIFE IS YOUR **LIFE**.
KNOW IT WHILE YOU **HAVE IT**.
YOU ARE MARVELOUS.
THE GODS WAIT TO DELIGHT IN YOU.

Letter Artist: Amy Foote, California to Vancouver

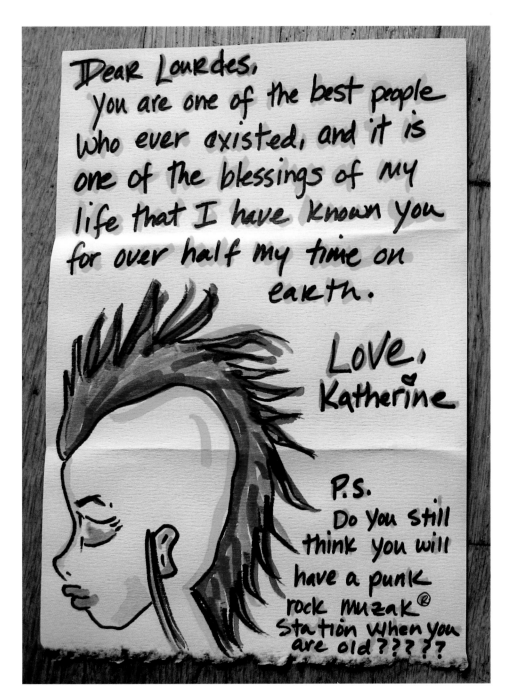

Letter Artist: Mary Thompson, California to California

August 6, 2011

Dear Erwin,

 It comes as a great delight to find a piece of mail that I have decided not to eat. As you know, I eat all of your mail. Today, is your day to celebrate and actually receive a piece of mail in your hands, from me.

 Hugs & Kisses,

 Your Mailbox

Letter Artist: Jennifer Hanley Knight, California to California

WELL HELLO THERE!

Letter Artist: Rachel Herbert, United Kingdom to Pennsylvania

Best Friend Inspection

- ☑ Breathtaking
- ☑ Tremendous
- ☑ Wonderful
- ☑ Fantastic

	1	2	3	4	5
Phenomelal......	1	2	3	4	⑤
Exceptional.........	1	2	3	4	⑤
Unusual............	1	2	3	4	⑤
Extraordinary......	1	2	3	4	⑤
Special............	1	2	3	4	⑤
Irreplaceable.....	1	2	3	4	⑤

Rating Key

5 exceeds all hopes/dreams
4 above average
3 mediocre
2 close, but no cigar
1 go home

Inspection Notes:

All around great best friend!

Letter Artist: Chelsea Hollow, California to Illinois

Love always,
Gail

Letter Artist: Sara Neppl, Washington to Pennsylvania

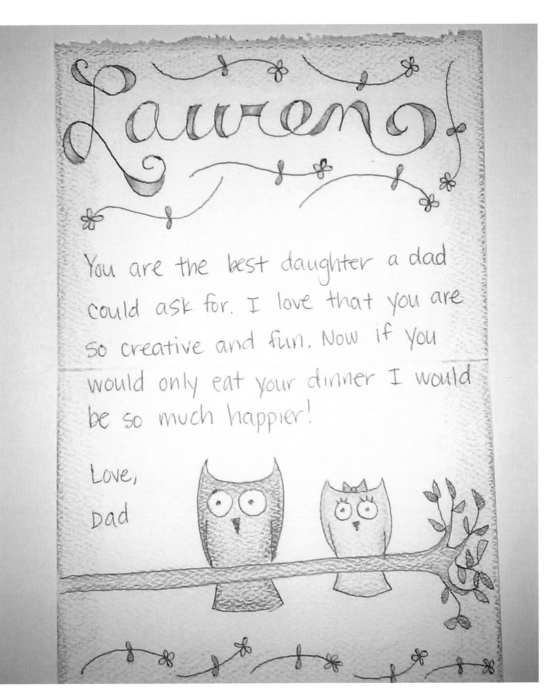

Lauren

You are the best daughter a dad could ask for. I love that you are so creative and fun. Now if you would only eat your dinner I would be so much happier!

Love,
Dad

Letter Artist: Heather Cash, California to Kansas

Dear Ryan,
Stop being a dumbass and write your grandma a letter once in a while.
Yours Truly,
Yourself

Letter Artist: Mary Thompson, California to Vermont

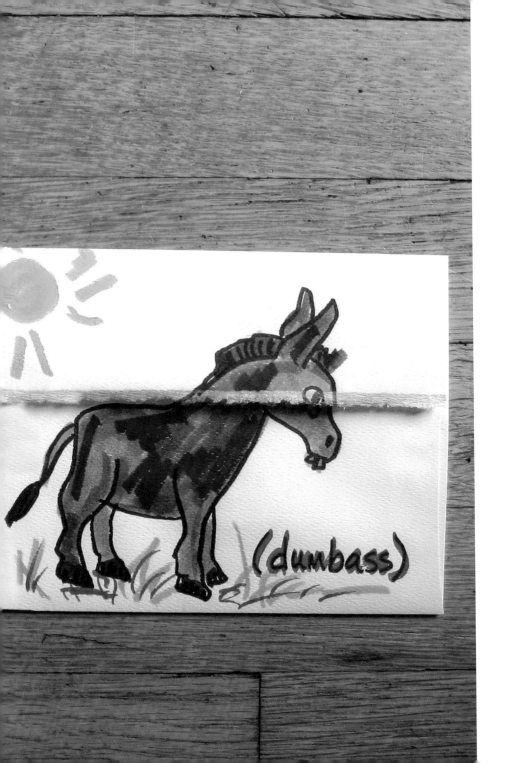

Translation from French:

Hello my lover,

I'm sending you this letter to tell you that I love you and am terribly fond of you. I very much look forward to coming back to Angers to see you. Kisses my lover.

I love you,
Adrien

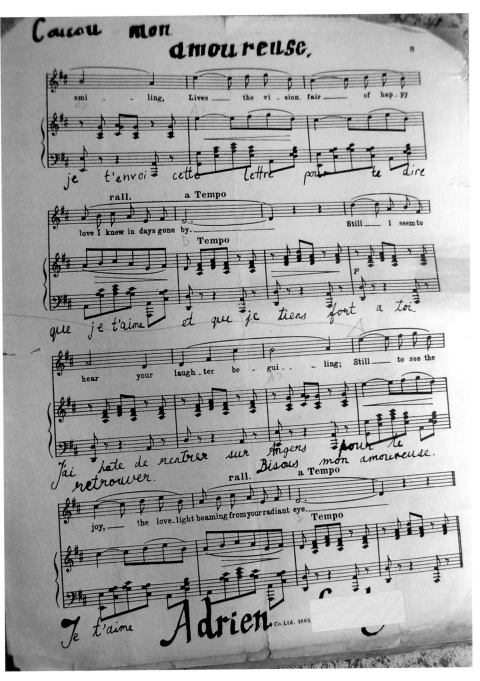

Letter Artist: Anna-Marie O'Brien, New Zealand to France

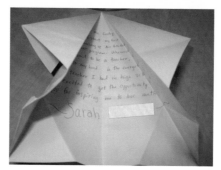

Letter Artist: Helo Lo, Canada to Minnesota

Ms. Gentry,

Tomorrow I start my first day

Student teaching at Air Academy

As part of my MAT program. Whenever anyone

asks why I want to be a teacher, the first

thing that pops into my head is the energetic and

encouraging math teacher I had in high school. Now

I'm terrified and excited to get the opportunity to take on

that role. Thank you for inspiring me to love math

Sarah

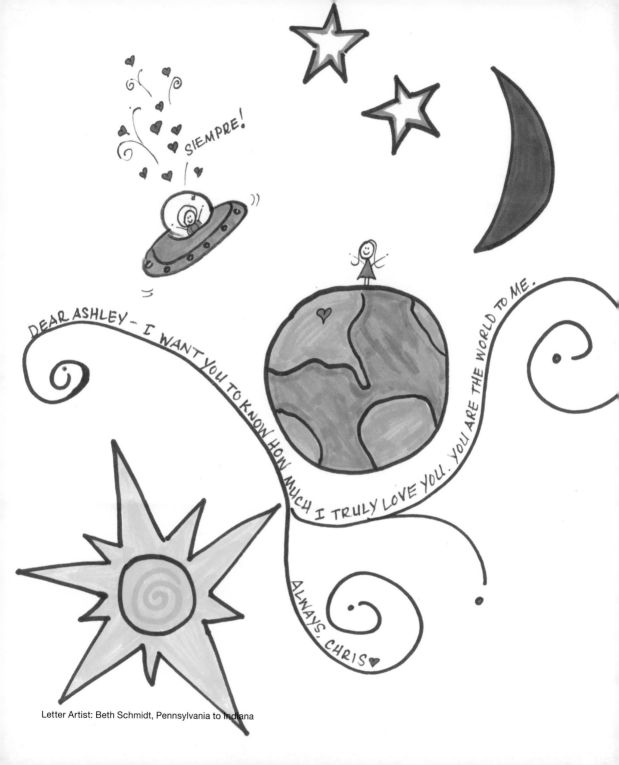

SIEMPRE!

DEAR ASHLEY — I WANT YOU TO KNOW HOW MUCH I TRULY LOVE YOU. YOU ARE THE WORLD TO ME.

ALWAYS, CHRIS ♥

Letter Artist: Beth Schmidt, Pennsylvania to Indiana

Dear Mindy,

To each of us, you are the "Snail Mail Queen" so we think it's only fitting to send our thanks this way. We appreciate your cards and letters, written in such beautiful penmanship, and all the love and smiles you put inside. For decades your kindness has brightened many a ho-hum day, and made it extraordinary! Thank you for taking the time to think of us on special occasions and the days in between. You give us a reason to look forward to the mail. Please forgive us for always sending email.

Love,
Your family
and friends

Letter Artist: Mary Thompson, California to California

Dear Brian,

You are a righteous dude. Sometimes life gets in the way and we forget to say it, but I just wanted to take a moment and say, yes, you are totally gnarly and radical. Can't wait to party down with you in a week or two. Hope all your shizz is totally kick ass and bodacious until then.

Your Friend,
Jeremy

Letter Artist: Ivan Cash, New York to Massachusetts

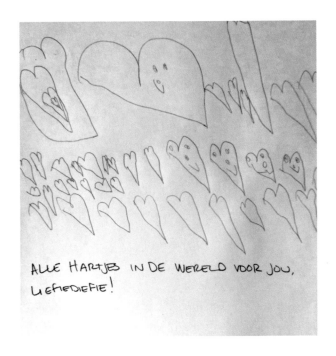

Translation from Dutch:

All the hearts in the world for you, Lovie-Dovie!

Letter Artist: Patricia Sikora, Minnesota to Netherlands

Dear Kris,

I never thought I'd fall in love @ 14. But here I am, head over heels in love with you & I've known you for 6 months. I'm still afraid to talk to you....

You're gorgeous, with stunning brown eyes and a charming smile. You're sweet, sensitive, funny, and charismatic.

You're also 14 years old.

Every night, my wish @ 11:11 is that you'll love me someday. In my heart I know it could be months, years before it happens. Maybe it will never.

Still...

I love you.

I always will♥

♥
♥
♥ From,
♥
♥ Anonymous♥ . . ♥ . ♥ ♥♥

Letter Artist: Theresa-Lee Palega, Connecticut to New Jersey

Dearest Jules,

We have been friends for longer than I thought Internet friends could last. You have no idea how much your friendship has changed me, and I cannot thank you enough for that. I love you darlin'!

Since Borders is Closing, I cannot offer you books, but the invitation to visit Chicago stands forever. I hope one day you can visit America, and one day I'll visit Germany. Or let's just meet in London and see some Marcus, Bobby and Sam?!

Take it easy sweetie!

Love
Jenny

Letter Artist: Feras Sobh, United Arab Emirates to Germany

"your life is your life.
know it while you have it.
you are marvelous."

D-bone, I miss you.
New York just isn't the same
Always your boo, k.

(that was a haiku)

Letter Artist: Charlotte Easterling, Wisconsin to United Kingdom

Hi Michelle!
I told you I would
send you a cup of

✗Ramen

DEAR NATATRON,

THIS IS KYLBOT,
WRITING TO YOU FROM
THE ALTERNATE
UNIVERSE WHERE WE
ARE ALL ROBOTS.

IF YOU ASKED ME
IF I MISS YOU, I WOULD
SAY "AFFIRMATIVE".

ALL OF MY CIRCUITS,

KYLBOT

Letter Artist: Sheila May Cervantes, Pennsylvania to Illinois

Letter Artist: Georgia Owen, United Kingdom to United Kingdom

Dearest Lynn,

written by me, designed by someone in this world, this letter comes to you with hope, for you and us. ^and love

^someone in ♥this world

I know we are going through a lot right now, but I am encouraged by us. ♥ It's my little sliver of hope that I hold dear. When ♥ it gets dark enough, you can see the stars. ! see stars, and hope ^to see the Milky way with you. ♥ One day

I also hope what they say is true, that love conquers all. ♥

Letter Artist: Kirsten Nielsen, Utah to Maryland

I WANT YOU TO KNOW
HOW MUCH I LOVE
 YOU.

♥ Love,
 Jen

July 27, 2011

Dear Andee,

When everything seems futile, just remember it is not as bad as you perceive it.

You can do anything, you just need to put forth the effort.

—Your past, your future and the people who truly love you.

Letter Artist: Cindy Arias, New Jersey to New Jersey

— Dear Deryn —

Ever since I was a wee thing I wrote lists. All kinds of lists— mostly wishlists, like things I wanted to buy, places I wanted to travel and musicians whose bums I wanted to pinch when I was old enough to go out and do so. One day I wrote my list for the perfect friend. She had to come with wise words, a gentle spirit and a sparkling personality. Oh and since I was at it, I'd added how I'd love if she could also be a bass playing, hoola-hooping champion, and maker of incredible disco rave sandwiches. It never occurred to me that this combination was impossible, more likely— surely, one in a million!

Check.

Love,

Holly.

Letter Artist: Maryam Hamzah, Malaysia to South Africa

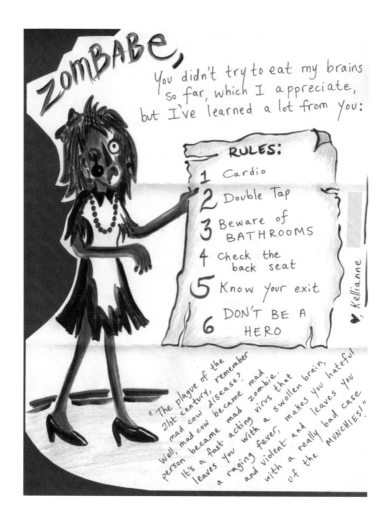

Letter Artist: Sarah Rosenberg, New York to North Carolina

DEAR TERRIE, I LOVE YOU. I KNOW I MAKE YOU MAD SOMETIMES, BUT I'LL ALWAYS BE

THERE FOR YOU. EVEN IF IT WAS THE END OF THE WORLD AND ZOMBIES ATE MY BRAINS

SCOTT

Letter Artist: Julie Dawson, Utah to Michigan

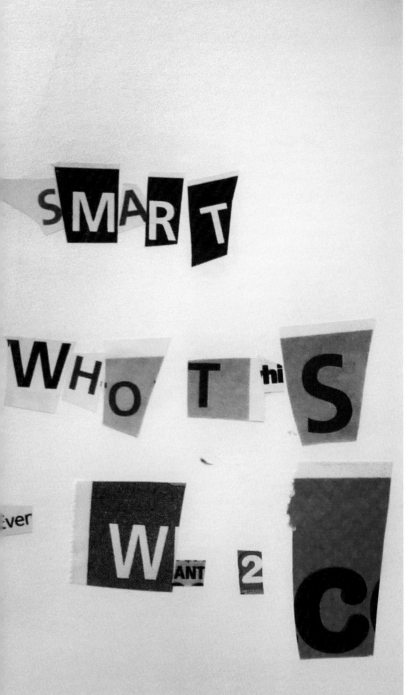

Letter Artist: Gideon Burdick,
Arizona to Connecticut

Letter Artist: Jessica Rice, Oregon to France

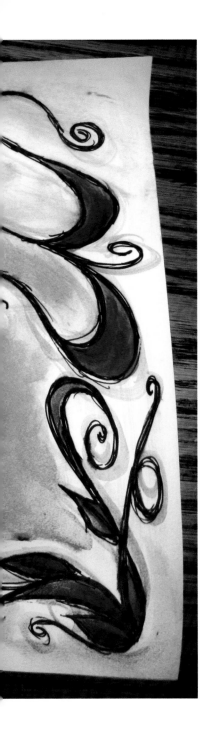

Translation from French:

Hello beautiful,

Here is a little geeky attention to tell you that I love you!

Alexis,
Your lover!

hey Lindsay,

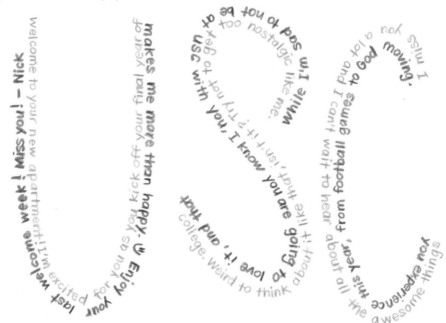

Letter Artist: JoLynn Pineda, California to California

Dear Jens,
 Misunderstandings
are gone like last year's snow.
Transparency is the new black.
 Thanks for being such an
·A·W·E·S·O·M·E· ·F·R·I·E·N·D·

If one day you miss the
 illustrations,
you can always find them here:
http://olesja.wordpress.com/2010/10/18/aromatic/

 Sincerely,
 O.

P.S.
I can't wait to see
what your new cafe
will look like!
 Wishing you
looots of $ucce$$!!!

Letter Artist: Sarah Rosenberg, New York to Finland

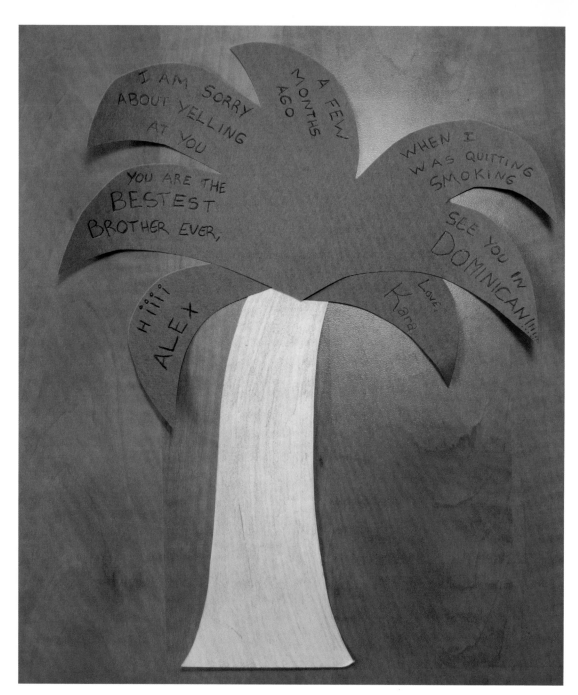

Letter Artist: Suzy Lafontaine, Canada to Canada

Elephantshoe

(I really do.)

The way you dance makes me flutter,
The way you look at me makes me melt like butter.
The way you hold me all night,
Makes me feel like everything in the world is alright.

You make me laugh, you make me sing,
You make me feel like I have wings.
I know what I have to say is cheesy,
but when talking about you, it's very easy

because,

Elephantshoe
I really, really do.

♡ Laura

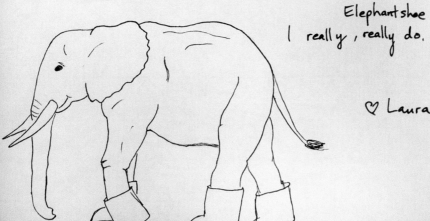

Letter Artist: Sheilla May Cervantes, Pennsylvania to California

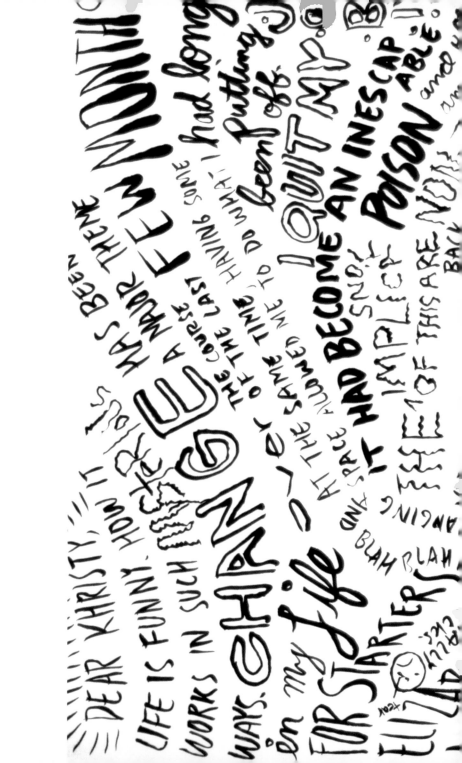

Letter Artist: Charles Chase,
Netherlands to Washington

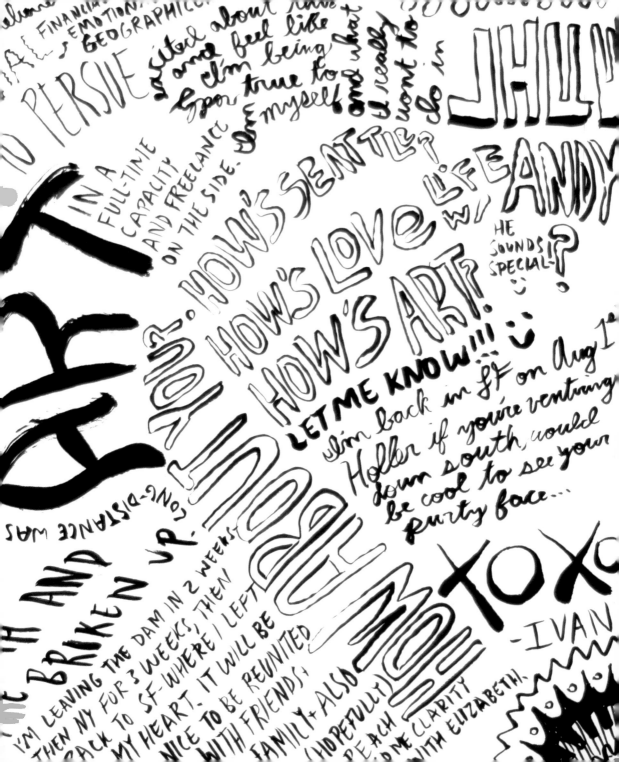

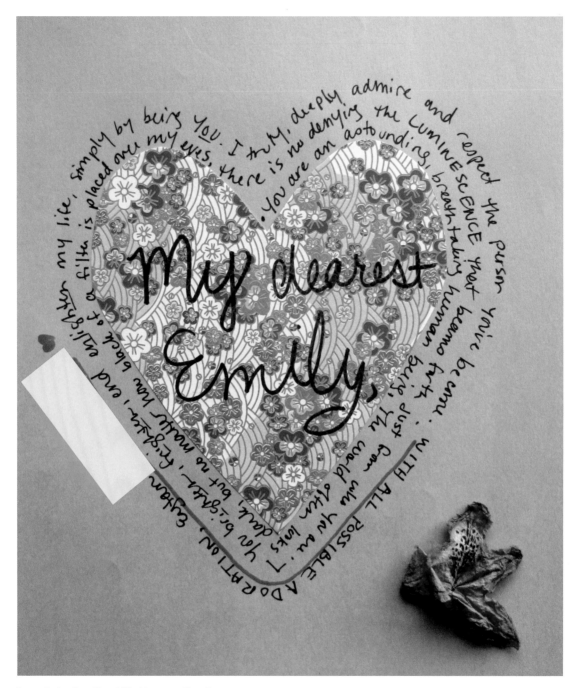

My dearest Emily,

simply by being _you_. I truly, deeply admire and respect the person you're becoming, breathtaking human being. Just from who you are... You are an astounding, the LUMINESCENCE that becomes you. There is no denying the enlighten my life. is placed over my eyes, there is no denying you brighten my world after lots. I you world with all possible ADORATION. frighten, but — mostly now black on black — and WITH ALL POSSIBLE ADORATION. You brighten, but — mostly now black on black — and of a filter

Letter Artist: Sara Neppl, Washington to New Jersey

Dave,

I want to say thank you. Thank you for your support and affirmation and prayers and for your passion for life and the easy way you laugh. Thank you for your soul.

You see beauty and splendor, despite the charred and broken bits of life. You bring out the best in me, you challenge me, and you give me grace. Every day with you I feel truly cherished, nourished, strengthened and at peace.

Your fingers interlaced with mine are exactly as they're meant to be.

May we never stop getting lost in each other, and in the glorious world we have been given.

Te amo.

Jasmine

Letter Artist: Jessica Lada Browning, Oklahoma to Canada

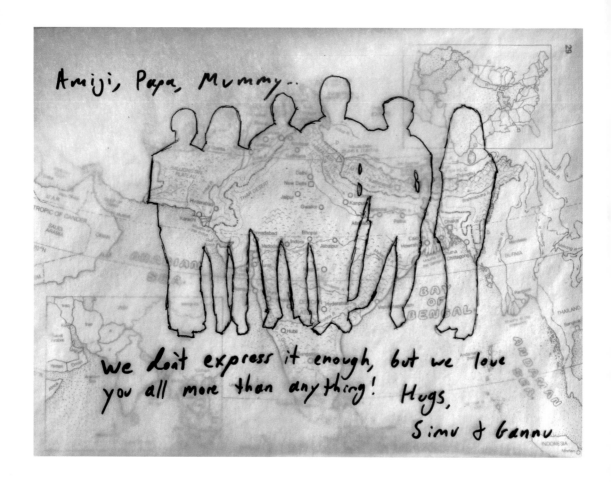

Letter Artist: Gideon Burdick, Arizona to India

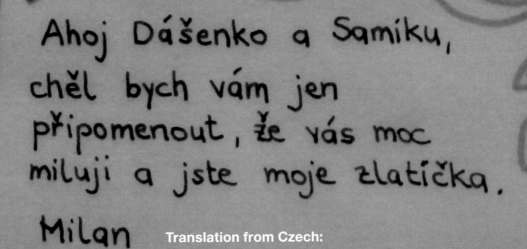

Ahoj Dášenko a Samíku, chěl bych vám jen připomenout, že vás moc miluji a jste moje zlatíčka.

Milan

Translation from Czech:

Hi Dasenka and Samik, I just wanted to remind you that I love you very much and that you're my sweeties. Milan

Letter Artist: Stefanie Beck, Germany to Czech Republic

I NOTICED THAT YOU POSTED AN ADDRESS TO REACH YOU AT CAMP. I BET YOU DIDN'T THINK I WOULD WRITE YOU. ANYWAYS I HOPE YOU ARE HAVING A GOOD TIME! REMEMBER, DON'T TALK TO ANY BOYS!

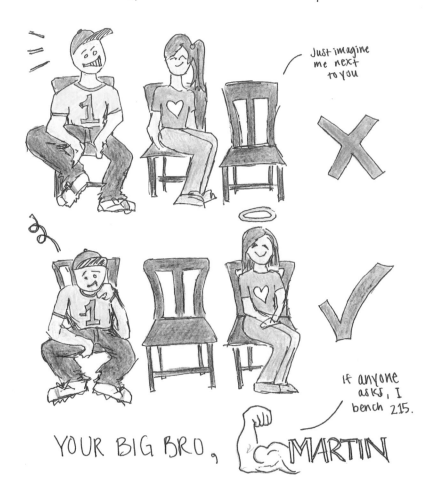

YOUR BIG BRO, MARTIN

Letter Artist: Lucy Tan, China to Canada

DEAR GINGA,

All the enemies of the Ninjas + Gingers have discovered our whereabouts. they are jealous of our awesomeness + wish to eradicate our friendship. I advise you report back to virginia immediately so we can band together + defeat those who are envious. Also, we can catch up on old times, by having tea + gossiping like old women on Bingo Night. This mission should be carried out immediately!

'Hope to see you soon, NINJA

Letter-Artist: Kristine Chong, California to Colorado

Letter Artist: Mary Thompson, California to Canada

f..........

HEY Brock

You need to have more meaningful relationships with people in your industry.

The Undersigned,

BROCK ████████

Graphic Design Communication

To my Family,

It is nice in Heaven! I get to run free and chase after squirrels all day. There is so much cheese and peanut butter for me to eat!

Thank you for taking me out on walks, even when it was freezing. Thank you for keeping me safe during thunderstorms and for kissing me goodnight.
Thank you for taking care of me all these years.
Thank you for loving me.
I wish you were here with me now but I know we will be reunited in the future.

Your puppy always,

Shadow

Letter Artist: Liz Dierbeck, Illinois to Minnesota

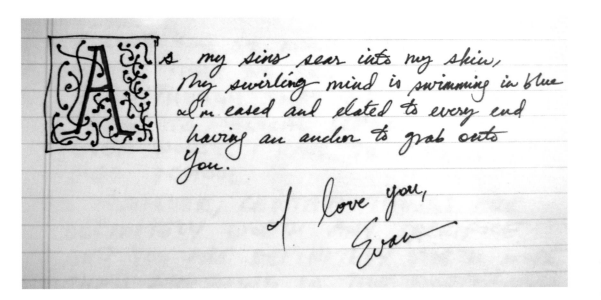

As my sins sear into my skin,
My swirling mind is swimming in blue
I'm eased and elated to every end
having an anchor to grab onto
You.

I love you,
Evan

Letter Artist: Teresa Vice, Washington, DC to Arizona

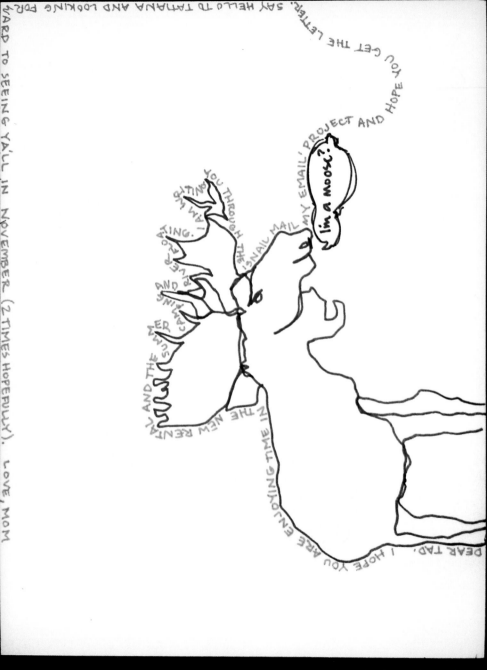

Letter Artist: Julie Dawson, Utah to Montana

dear alissa,

FRESH

Oh my, how have passed. the years quickly I can still remember when I lived without you in my life, and now you are starting your first year in high school. Has it really been 13 approaching 14 years already? You will be learning more about yourself,

Be fearless – break out of your bubble, and meet new people.

Make every day count, and be happy.

Here's to a great high school experience!

Letter Artist: JoLynn Pineda, California to California

society, and the world these next four years, and I hope that you will take advantage of every opportunity that comes your way to make a difference in the world.

Always smiling.

Your loving sister,
aka *Madame*
Student Body President

Angela

*** Meep ***

YOU ARE THE MOST BEAUTIFUL INDIVIDUAL I KNOW. XX 'EMA

Letter Artist: Julie Dawson, Utah to New Zealand

Dear Alicia,

You are the best girlfriend in the entire world and I wish I could play songs for you like you do for me. I don't think you understand how much you mean to me. I mean, who else would bring me roses and learn Sublime songs for me? No one. I'm going to marry you one day, I pinky swear.

I love you. Olivia

Lovin' is what I got, I said remember that. Lovin' is what I got. Lovin' is what I got, I said remember that. Lovin' is what I got, I said remember that. Lovin' is what I got, I said remember that. Lovin' is what I got. Lovin' is what I got, I said remember that. Lovin' is what I got.

Letter Artist: Sheilla May Cervantes, Pennsylvania to Delaware

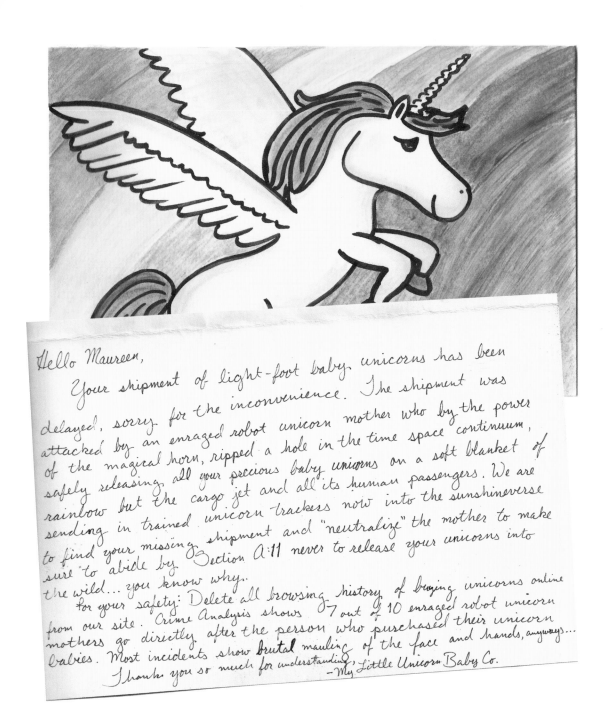

Hello Maureen,

Your shipment of light-foot baby unicorns has been delayed, sorry for the inconvenience. The shipment was attacked by an enraged robot unicorn mother who by the power of the magical horn, ripped a hole in the time space continuum, safely releasing all your precious baby unicorns on a soft blanket of rainbow but the cargo jet and all its human passengers. We are sending in trained unicorn trackers now into the sunshineverse to find your missing shipment and "neutralize" the mother to make sure to abide by Section A:11 never to release your unicorns into the wild... you know why.

For your safety: Delete all browsing history of buying unicorns online from our site. Crime Analysis shows 7 out of 10 enraged robot unicorn mothers go directly after the person who purchased their unicorn babies. Most incidents show brutal mauling of the face and hands, anyways...

Thank you so much for understanding, Little Unicorn Baby Co.

— My Little Unicorn Baby Co.

Letter Artist: Chelsea Hollow, California to Connecticut

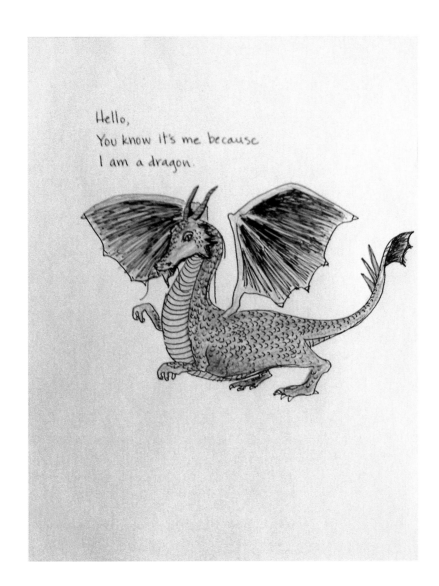

Letter Artist: Aya O'Connor, Illinois to India

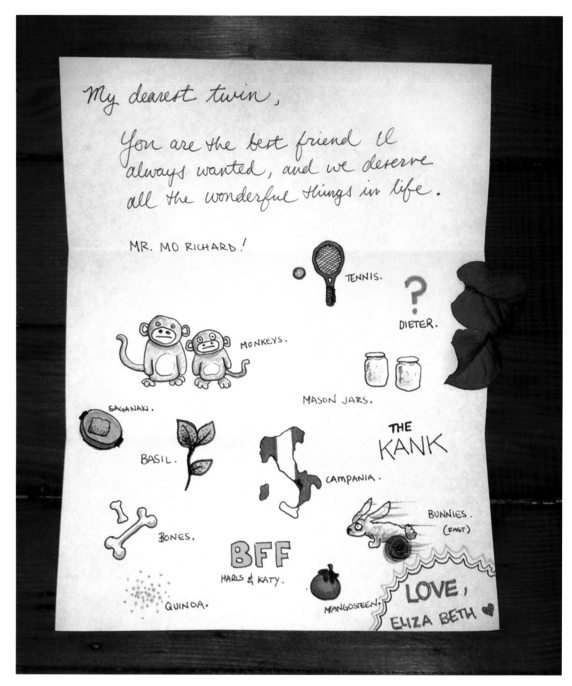

Letter Artist: Blaine Vossler, California to Indiana

SHANNON,
WE WERE ONCE SO CLOSE THAT OUR HANDS
MADE SMALL FOOTHILLS, CLASPED TOGETHER,
OUR KNUCKLES SNOWCAP- WHITE.

I DON'T KNOW HOW WE LOST EACH OTHER –
IT MUST HAVE STARTED WITH SOME IDEA OF SPACE, FREEDOM,
SPREADING OUR FINGERS, NOT KNOWING HOW TO CATCH AGAIN

I'M SO GLAD WE HAVE ONCE AGAIN FOUND CLOSENESS
YOU WERE MY FIRST FRIEND, A FRIEND I NEVER WANT TO LOSE.
I LOVE YOU SISTER, AND THIS IS JUST A REMINDER OF THAT.

LOVE,
YOUR LITTLE SIS

Letter Artist: Stefanie Beck, Germany to Indiana

7 August 2011

Hello,

I hope you are well.
Australia is a big country – it's
probably very easy to get lost in.
Please stay safe. All of the wallabies
would become weepy should you
become a wanderer.

You probably don't remember me. It was
so very long ago when we met. (I've included
a small drawing of myself to help jog your
memory) We were in the local Woolsworths and
we were both racing towards the spreads and
dips aisle. Alas, there was only one lonely tin
of vegemite remaining. I was ready to turn
and leave, sadly thinking of the dry toast
that I had left on my kitchen counter
that would forever remain so because
of the lack of vegemite. Suddenly, you
offered the tin of brown smeary glop to
me. I would have liked to have said 'I love
you' right then and there, but believed that
would have been too forward. However, I will
always remember you.

Thank you, Mr. P

Letter Artist: Ang Puay Lin,
Singapore to Australia

Translation from German:

Dear Maren,

I have found a treasure,
and it bears your name.
So beautiful and precious,
so invaluable that not even all of
the world's riches could compare.

You drift off to sleep next to me,
I could spend all night watching you.
To see how you sleep, to hear you breathe
until we wake up in the morning.

Once again you have managed
to take my breath away.
When you're lying next to me,
I can hardly believe how someone like me could
deserve someone as beautiful as you.

You are the best thing that ever happened to me.
It feels so good to be loved by you like this.

Yours

Liebe Maren,

Ich habe einen Schatz gefunden,
und er trägt deinen Namen.
So wunderschön und wertvoll
mit keinem Geld der Welt zu bezahlen.

Du schläfst neben mir ein
ich könnt dich die ganze Nacht betrachten.
Sehn wie du schläfst,
hörn wie du atmest,
bis wir am Morgen erwachen.

Du hast es wieder mal geschafft,
mir den Atem zu rauben.
Wenn du neben mir liegst,
dann kann ich es kaum glauben,
dass jemand wie ich
so was Schönes wie dich verdient hat.

Du bist das Beste was mir je passiert ist
es tut so gut wie du mich liebst.

Dein

Letter Artist: Jessica Rice, Oregon to Germany

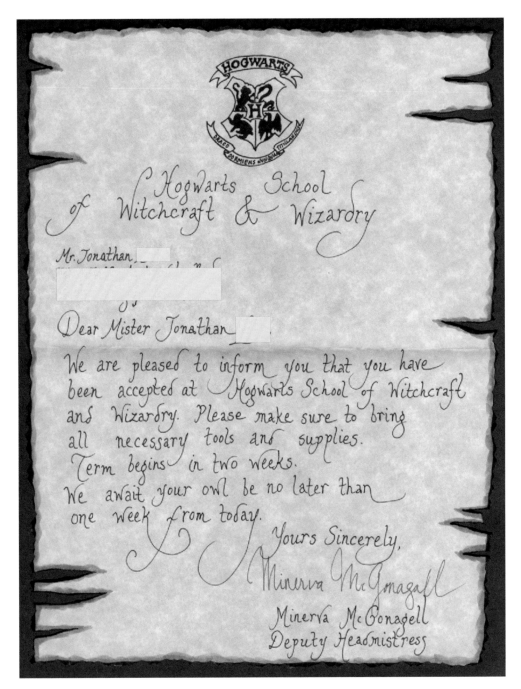

HOGWARTS

Hogwarts School of Witchcraft & Wizardry

Mr. Jonathan ▮

Dear Mister Jonathan ▮

We are pleased to inform you that you have been accepted at Hogwarts School of Witchcraft and Wizardry. Please make sure to bring all necessary tools and supplies. Term begins in two weeks.

We await your owl be no later than one week from today.

Yours Sincerely,

Minerva McGonagell

Minerva McGonagell
Deputy Headmistress

Letter Artist: Sarah Rosenberg, New York to Singapore

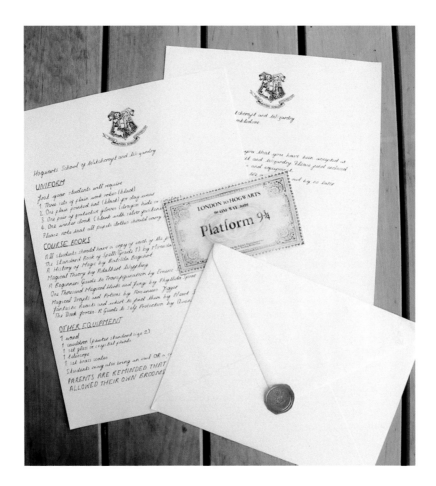

Letter Artist: Georgia Owen, United Kingdom to United Kingdom

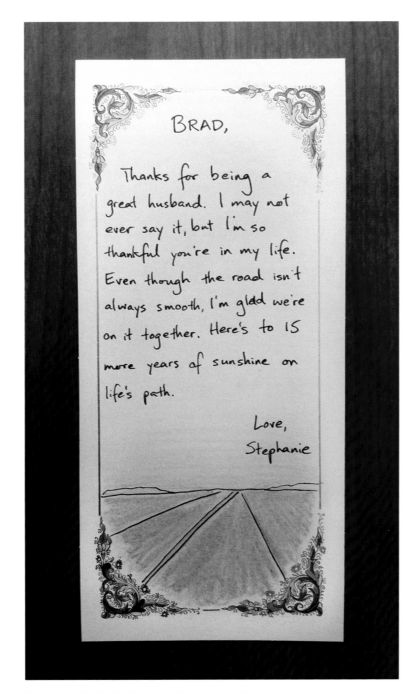

BRAD,

Thanks for being a great husband. I may not ever say it, but I'm so thankful you're in my life. Even though the road isn't always smooth, I'm glad we're on it together. Here's to 15 more years of sunshine on life's path.

Love,
Stephanie

Letter Artist: Sheilla May Cervantes, Pennsylvania to Iowa

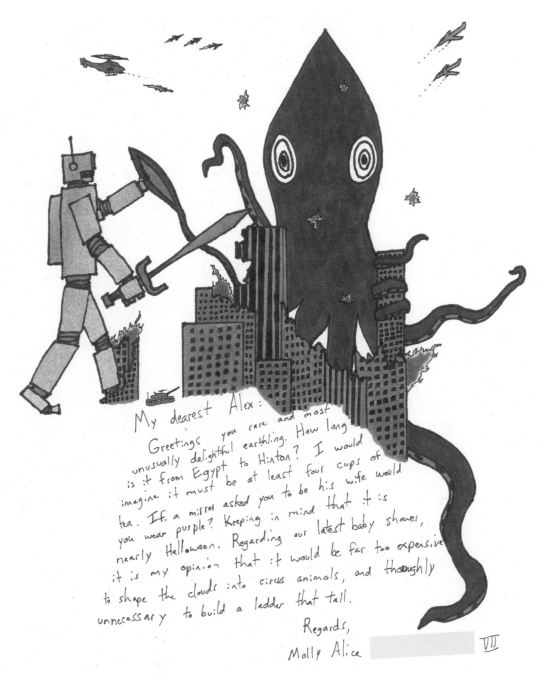

My dearest Alex:

Greetings you rare and most unusually delightful earthling. How long is it from Egypt to Hinton? I would imagine it must be at least four cups of tea. If a mirror asked you to be his wife would you wear purple? Keeping in mind that it is nearly Halloween. Regarding our latest baby shower, it is my opinion that it would be far too expensive to shape the clouds into circus animals, and thoroughly unnecessary to build a ladder that tall.

Regards,

Molly Alice

VII

Letter Artist: Chris Boyce, New York to West Virginia

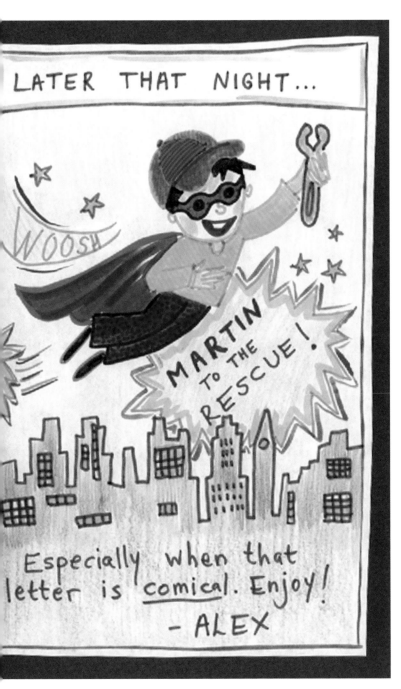

Letter Artist: Sarah Rosenberg, New York to Canada

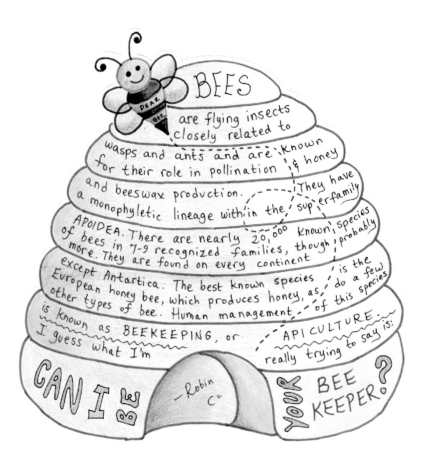

BEES are flying insects closely related to wasps and ants and are known for their role in pollination & honey and beeswax production. They have a monophyletic lineage within the superfamily APOIDEA. There are nearly 20,000 known species of bees in 7-9 recognized families, though probably more. They are found on every continent except Antartica. The best known species is the European honey bee, which produces honey, as do a few other types of bee. Human management of this species is known as BEEKEEPING, or APICULTURE. really trying to say is: I guess what I'm

CAN I BE YOUR BEE KEEPER?

~Robin C~

PEAR BEE

Letter Artist: Sarah Rosenberg, New York to Pennsylvania

3 August, 2011

Minun Anni,
 There is no one who eats lemons like you do. And it makes me want to hug you.

Letter Artist: Jennifer Hanley Knight, California to Finland

HELLO STEVEN:

I AM SENDING YOU THIS PIECE OF ORIGAMI FROM TEH FUTURE.

We now have people that send us handwritten letters instead of us having to send them ourselves.

It is very retro having paper letters mailed to us again and hope you appreciate how much money it cost me to send you this one.

Hope you had fun at that surprise party that is coming up — I KNOW I DID!

Sincerely,

Steven

P/S/ We have a length limit similar to Twitter, except now we can only write 100 words. Sadly this is often not enough for

NOTICE from writer: Please read aloud in ROBOT VOICE.

MADE IN U.S.A.

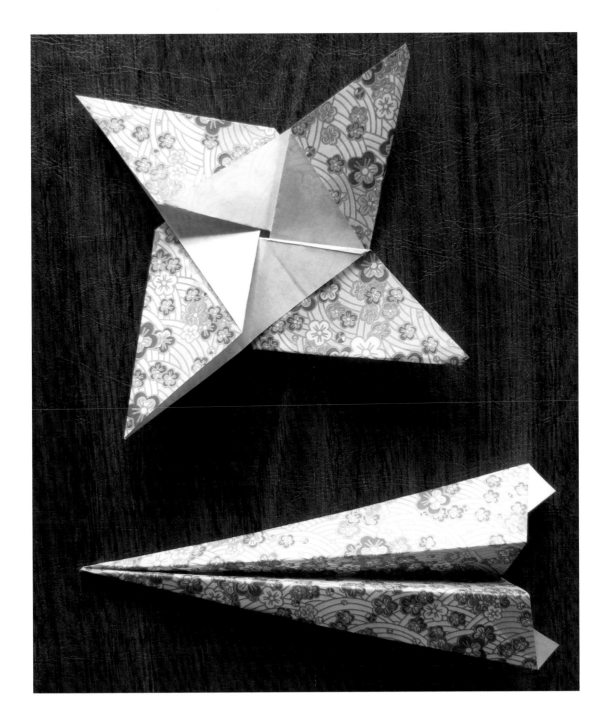

DEAR MEG,
Thought this would
brighten your day ☺

10 Aug 2011

"my
advice to
you is not
to inquire
why or
whither,
but just enjoy
your ice cream
while it's on
your plate."

Enjoy!

thornton
wilder

Letter Artist: Kristine Chong, California to Vermont

FORWARD!

ONE FOOT IN FRONT OF THE OTHER

Rachel........

My therapist told me something I think applies to us both: Growing up in a neglectful/Dysfunctional /etc house is like living in a burning building. Getting out of the burning building is hard - but it's even harder to not run into the building again. Example: if I let my father continue to manipulate me emotionally, instead of living my own life now that I'm an adult, that's running back into the burning building. It's like he's standing in the burning building yelling, "Come back! There's nothing wrong!" even though the building is clearly on fire.

I think that we've both escaped our burning building and haven't run back in. We'll probably always be tempted to run back into it, in some manner. Let me know if you need a reminder that it's on fire.

Love, Tracie

Letter Artist: Mary Thompson, California to Maryland

HI SISTER,

JUST WRITING TO SAY I
I CAN'T WAIT FOR US TO
AND FABULOUSLY WEALTHY
ALL THE TIME. UNTIL THE

XO MISSY

Letter Artist: Stefanie Beck, Germany to United Kingdom

VE YOU AND MISS YOU.
COME WILDLY SUCCESSFUL
WE CAN VISIT EACH OTHER
HERE'S SKYPE.

Amor,

Eu sinto falta de você hoje, assim como senti ontem e assim como vou sentir amanha!

-♥ Bjs

Translation from Portuguese:

Love, I miss you today, just like I missed you yesterday and will miss you tomorrow!

Kisses

Letter Artist: Aya O'Connor, Illinois to Brazil

grazie

alstublieft

Dear Jessie

Thank you for replying to my overly-dramatic text messages.

kia ora Thank you for lending me money when I'm desperately broke

jeir

gràtia Thank you for listening to me complain about being the middle child and feeling neglected

bene Thank you for washing the pots whenever I'm sent to do the dishes

facis Thank you for not getting mad for using your Mac (even after spilling orange soda on it)

Thank you for taking care of me
 for putting my interests above yours
 telling me what's right and wrong
 parenting me giving me hope
 believing in me

merci

DANKE

Being my sister and the world's greatest, most loyal best friend.
For loving me

 Thank you. For everything

gracias

fa'afetai

Love, Karen.

благодарность

agradecer muito obrigada

P.S. I'm glad you're not here with children who need you more than I do because I have you for the rest of my life and they only have you for one summer... and I'm sure you've made it their best

Letter Artist: Anna-Marie O'Brien, New Zealand to New Hampshire

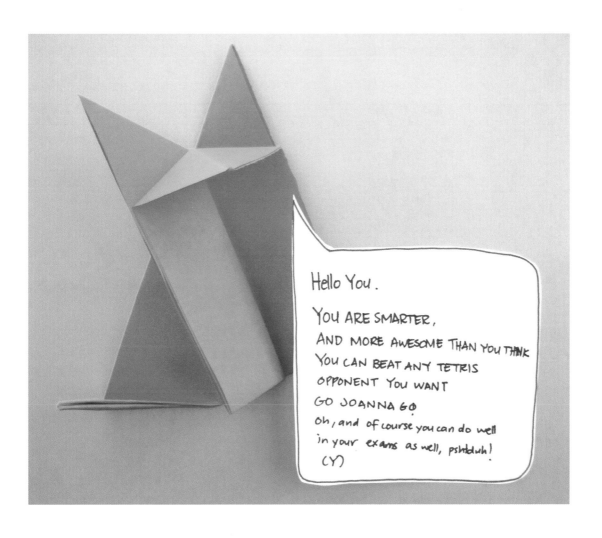

Letter Artist: Maryam Hamzah, Malaysia to Singapore

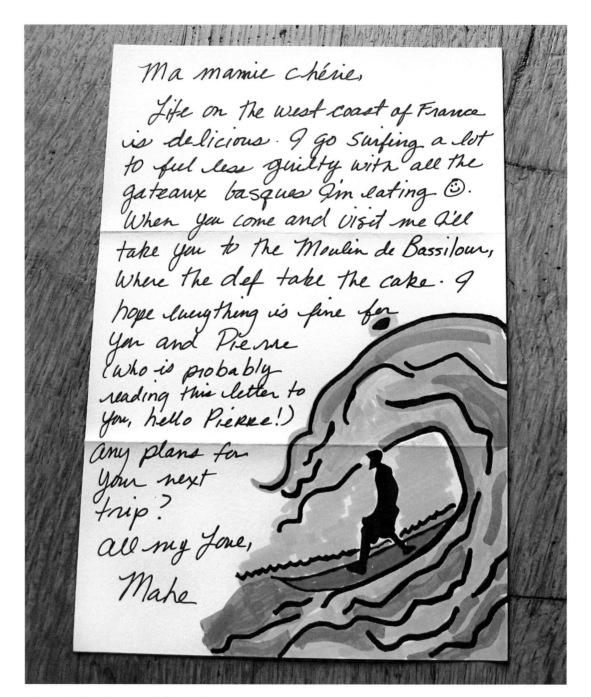

Ma mamie chérie,

Life on the west coast of France is delicious. I go surfing a lot to feel less guilty with all the gateaux basques I'm eating ☺. When you come and visit me I'll take you to the Moulin de Bassilour, where they def take the cake. I hope everything is fine for you and Pierre (who is probably reading this letter to you, hello Pierre!) Any plans for your next trip?
All my love,
Mahe

Letter Artist: Mary Thompson, California to France

July 27, 2011

Dear Rach,

Just thought I'd get somebody else to send you a letter to show you how much I love you.

You are my best friend and you deserve random surprises, including a message emailed by a random stranger in a non-sweatshop environment.

Love you so much, you are my best friend. Here is a picture of a bear riding a dragon into space.

Love Jus

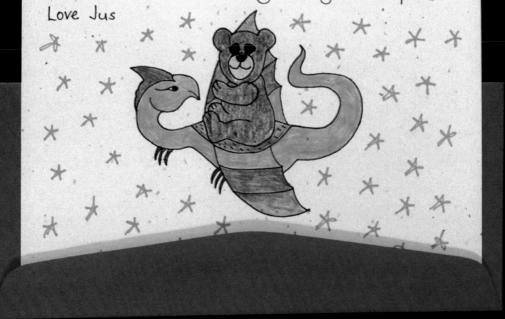

Letter Artist: Cindy Arias, New Jersey to Australia

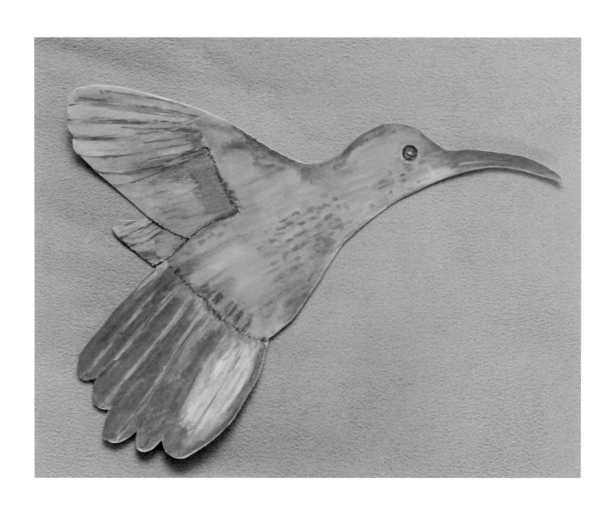

Letter Artist: Stefanie Beck, Germany to Singapore

HARLO WOOLA!!! ♥ THIS LETTER IS A RANDOM LETTER TO TELL YOU THAT YOU ARE ONE OF MY MOST SPECIAL FRIENDS EVER AND THAT YOU ARE SUCH AN AMAZING FRIEND BACK AND THAT IF YOU ARE NOT THE SOME-EST AND AMAZING AND GENUINE AND AWESOME AND THAT YOU ARE REALLY AND SPECIAL-EST AND AMAZING AND GENUINE AND THAT I MISS YOU A LOT AND LOVES YOU A LOT AND SHER LOVES YOU 2 AND THAT I'M SORRY PERSON SHER LOVES YOU AND OUT YAY! AND THAT I'M SORRY THAT YOU AND THAT WE DON'T TALK SO MUCH ANYWAY ORE — AND THAT I'M SORRY AGAIN (I'LL FOR NOT BEING SHOULD LOVE YOURSELF TEN 2/0 MILLION TIMES MORE

LOVE FROM SHER (A BIT OBVIOUSLY)

Letter Artist: Mary Thompson, California to Illinois

Hello. I am from space. You may not know this but chickens have gone extinct in the year 4000... yeah... sorry about that. Pollo Loco went out of business. But, the space cows still roam free... their moos are different now though. Ever since the chickens left the cows have taken up the chickens' sgawk. It's a devastating sight to see. So my advice is to stop developing the robotic roomba floor cleaners. Because in a few years they will take over & kill all the chickens. Yeah. That's how they died. Those robots love them some chicken.

SO. Good luck. —A Space Time Traveler

Letter Artist: Liz Dierbeck, Illinois to California

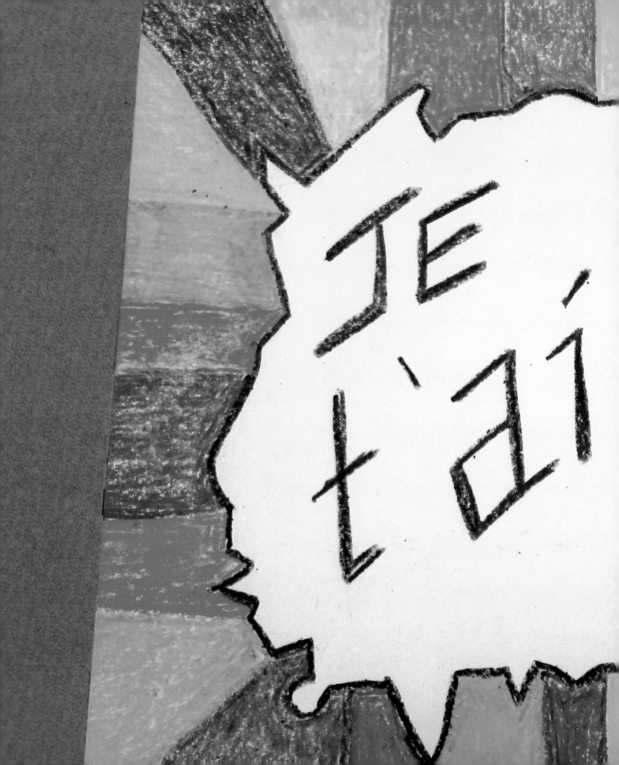

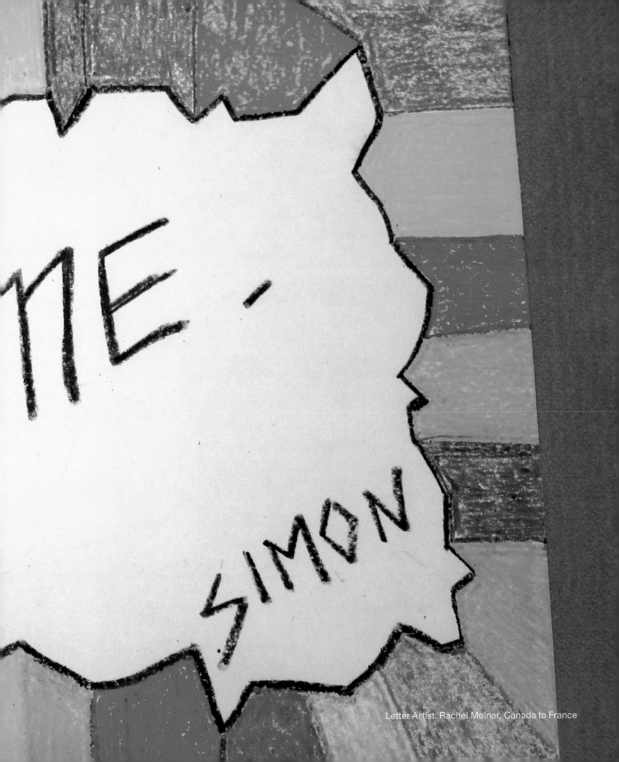

Letter Artist: Rachel Molnar, Canada to France

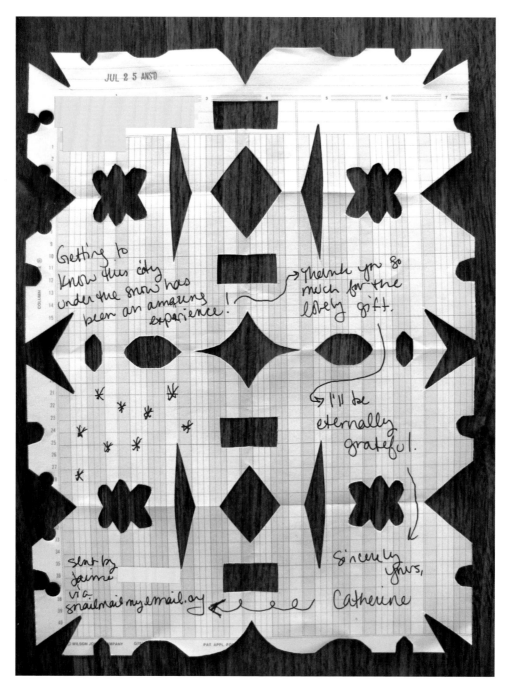

Letter Artist: Sara Neppl, Washington to Brazil

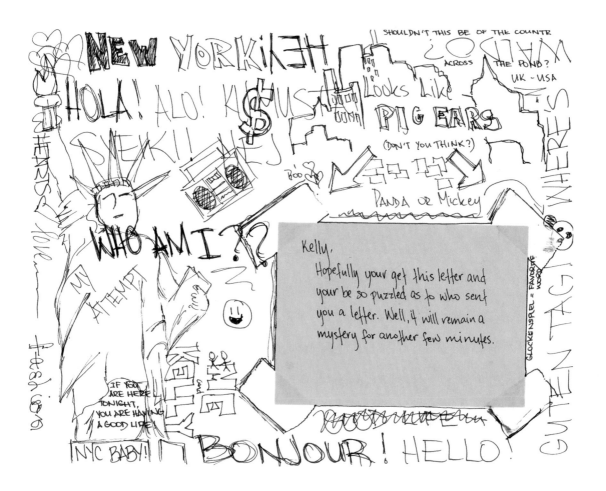

Kelly,

Hopefully your get this letter and your be so puzzled as to who sent you a letter. Well, 4 will remain a mystery for another few minutes.

Letter Artist: Nikki Santiago, New Jersey to United Kingdom

zij was er ineens
geheel onverwacht
en zij was de wereld
de dag en de nacht

De tafel de stoelen
het brood en het bed
mijn eerste mijn tweede
en laatste couplet

de lach die ze lacht
is al bijna een kus
ze past in mij armen
het sluit als een bus

ik hou van je, ik hou van je
stamel ik zacht
dat is de liefde
ze komt onverwacht

je kunt haar niet zoeken
niet vragen niet wenken
niet organiseren
en ook niet bedenken

ze is er ineens
geheel onverwacht
en zij is de wereld
de dag en de nacht

~Kus Jasper

Letter Artist: Jessica Franken, Minnesota to Netherlands

Translation from Dutch:

Suddenly she was there
Completely unexpected
And she was the world
The day and the night

The table, the chairs
The bread and the bed
My first, my second
And last couplet

That laugh that she has
Is already almost a kiss
She fits in my arms
It connects like a bus

I love you, I love you
I softly stammer
This is love
She comes unforeseen

You can't search for her,
Ask for her, or beckon
She can't be organized
And can't be imagined

Suddenly she is there
Completely unexpected
And she is the world
The day and the night

—Kiss

BEAR,

I AM MORE THAN BLESSED TO HAVE YOU IN MY LIFE.

LOVE, PIE

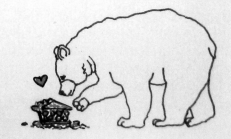

Letter Artist: Julie Dawson, Utah to California

Voucher # 00711

TO REDEEM
ONE PAIR OF
WINGS ONLY

T&Cs:
1. Colour and size of wings are given at random, and cannot be exchanged or returned unless they are found to be defective or damaged.
2. Please only use wings under good weather conditions, flight under bad conditions is not advised.
© 2000-2011 Winging It Co. ^^ˇ

Hi Cameren,

I was just wanting to say thank you for watching Leia. It means a lot to me and let me know when you want to go got wings. Just call me!

Love you,
Papoo

Letter Artist: Ang Puay Lin, Singapore to Indiana

SUMMER 2011

DEAR CHRIS,

WHAT A GREAT SUMMER
WE ARE HAVING! I SO
ENJOYED OUR KAYAKING
TRIP TO THE DELAWARE
RIVER AND LOOK FORWARD
TO OUR TRIP TO YELLOWSTONE
AND THE TETONS. I HOPE
THE FISHING IS GREAT FOR
YOU OUT WEST. YOU ARE
SUCH AN EXPERT ANGLER.
AS FOR ME...

YOU'VE GOT ME
HOOKED!

MAD LOVE FROM YOUR
FISHING-WIDOW WIFE,
AMY

Letter Artist: Aya O'Connor, Illinois to Pennsylvania

Dear Mom,

By the time you are reading this I'm probably on the MV EXPLORER sailing to Morocco

Honestly, I can't believe that you let me sail AROUND THE WORLD. But, DON'T WORRY! I'm being safe while I'm having THE TIME OF MY LIFE!!! Even though I miss you A LOT, I just wanted to say thank you for letting me go on this VOYAGE.

THANK YOU!

LOTS OF LOVE,
KIMBERLY

MV EXPLORER

Letter Artist: Sarah Rosenberg, New York to Pennsylvania

DEAREST LEAH,

I CAN ONLY IMAGINE WHAT THE
FUTURE HOLDS FOR US.
I LOVE YOU

 - SIR JULIAN OF MAPLES

P.S. CAN WE HAVE „TACO BELL"
 TONIGHT ?

Würzm
Mélange d'ép

Letter Artist: Stefanie Beck,
Germany to Arkansas

Translation from Polish:

"Let your hands move about,
Let your head work things out,
'Cause you're wondering on and on,
Where's this postcard coming from."

Maciej

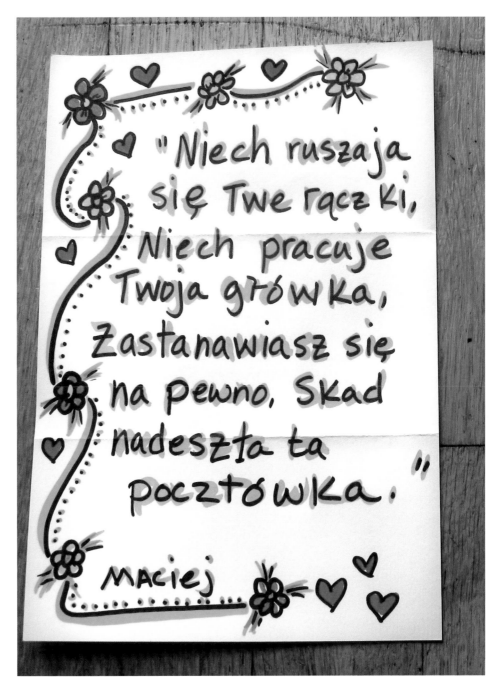

"Niech ruszaja się Twe rączki, Niech pracuje Twoja główka, Zastanawiasz się na pewno, Skad nadeszła ta pocztówka."

Maciej

Letter Artist: Mary Thompson, California to Poland

Dear Tiny Little Embryos,
Tomorrow Mommy + Daddy go to the fertility clinic to get you. The doctors + nurses will place you in Mommy's womb. We hope you will grow big + strong there and then be born nine months later very healthy + content. We love you already, so much.

Love, Mommy + Daddy

Letter Artist: Charlotte Easterling, Wisconsin to New York

Michelle, my beautiful wife,

Love is patient, Love is kind,
It does not envy, it does not boast,
It is not proud, it is not rude,
It is not self-seeking,
It is not easily angered,
It keeps no record of wrongs.

Love does not delight in evil,
but rejoices with the truth.

Love always protects, always trusts,
always hopes, always perseveres.

Love bears all things, believes all things,
hopes all things, endures all things.

Love never ends.

Love never fails.

- CORINTHIANS 13:4-8

Love, Scott XxXxXx

Letter Artist: Aya O'Connor, Illinois to United Kingdom

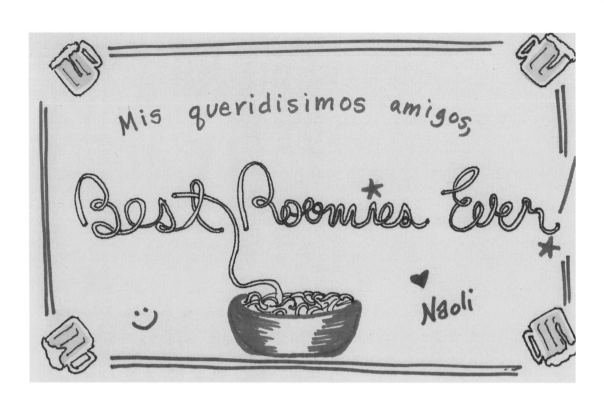

Letter Artist: Kristine Chong, California to Maryland

My dearest Rachell,

I have never forgotten the love we shared. I want you to know I've waited for you, and will always wait for you, to come home. The memory of your beauty warms me on cold nights.

yours,
Brother

Letter Artist: Laura Wiesner, Minnesota to Arizona

Dear Eugene,

The Very Beginning
The lines in your face, gazing at me over the picnic table; those early love letters; our shared love of the dharma.

In The Middle
Merging our life streams— opening the apartment wall; opening our hearts more & more as we traverse the 10,000 joys and sorrows.

Until The Very End
You will always be the love of my life.

One Heart, Sweetheart.
ILYVM!!
xoxx
—P—

Letter Artist: Amanda Wilson, Iowa to California

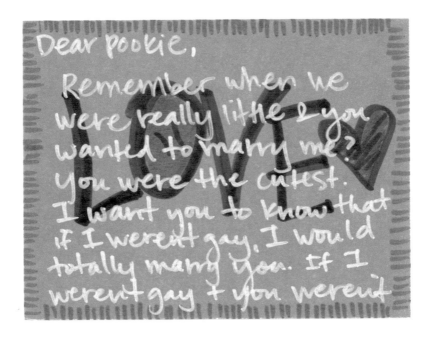

Dear Pookie,

Remember when we were really little & you wanted to marry me? You were the cutest. I want you to know that if I weren't gay, I would totally marry you. If I weren't gay & you weren't

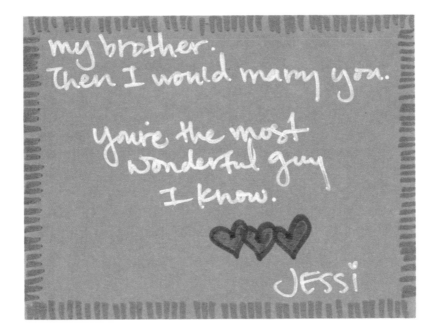

my brother.
Then I would marry you.

you're the most wonderful guy I know.

JESSI

Letter Artist: Kristine Chong, California to Oklahoma

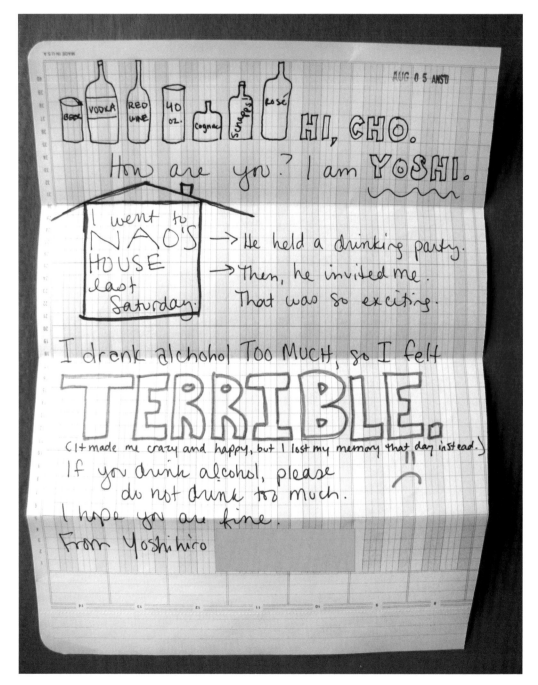

Letter Artist: Sara Neppl, Washington to South Korea

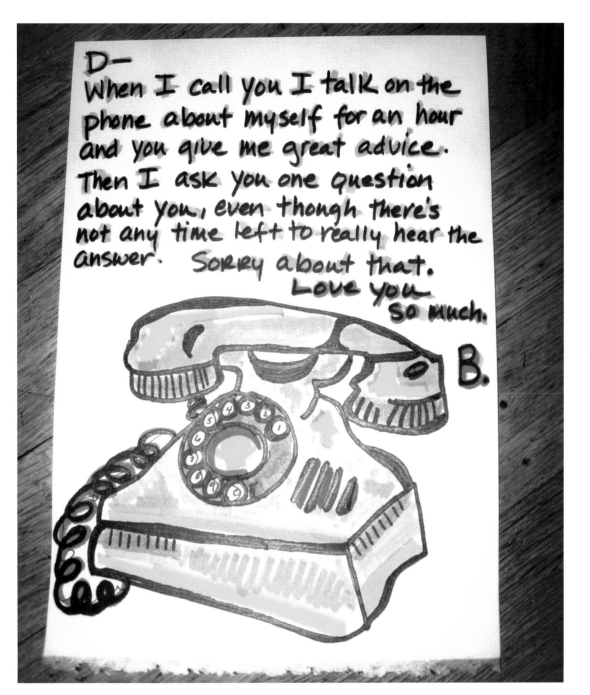

D—
When I call you I talk on the phone about myself for an hour and you give me great advice. Then I ask you one question about you, even though there's not any time left to really hear the answer. Sorry about that. Love you so much.

B.

Letter Artist: Mary Thompson, California to Canada

24/07/2011

Mon Pamplemousse,

 Je t'envoie cette lettre pour marquer nos 1 ans de relation. C'est illustration de l'amour que je te porte et également l'illustration du bonheur d'être aveco toi. Tu es une personne importante pour moi et j'éspére que tu recevras encore de nombreuses lettres de ma part chaque mois d'Aout... Je t'aime.

Kiwi

Translation from French:

I am sending you this letter to celebrate our first year together. It's illustrating the love I have for you, as well as how happy I am to be with you. You are a very important person to me and I do hope you will receive many letters from me every August…I love you.

Kiwi

Letter Artist: Cindy Arias, New Jersey to France

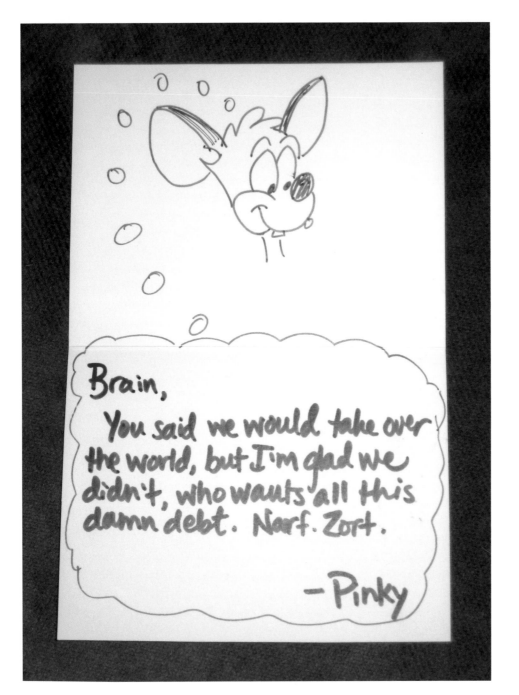

Letter Artist: Liz Dierbeck, Illinois to Massachusetts

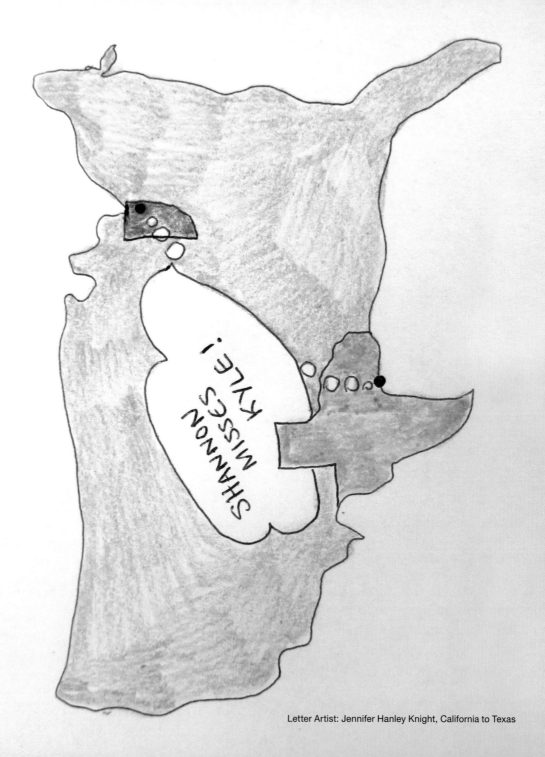

SHANNON MISSES KYLE!

Letter Artist: Jennifer Hanley Knight, California to Texas

Letter Artist: Amy Foote, California to Missouri

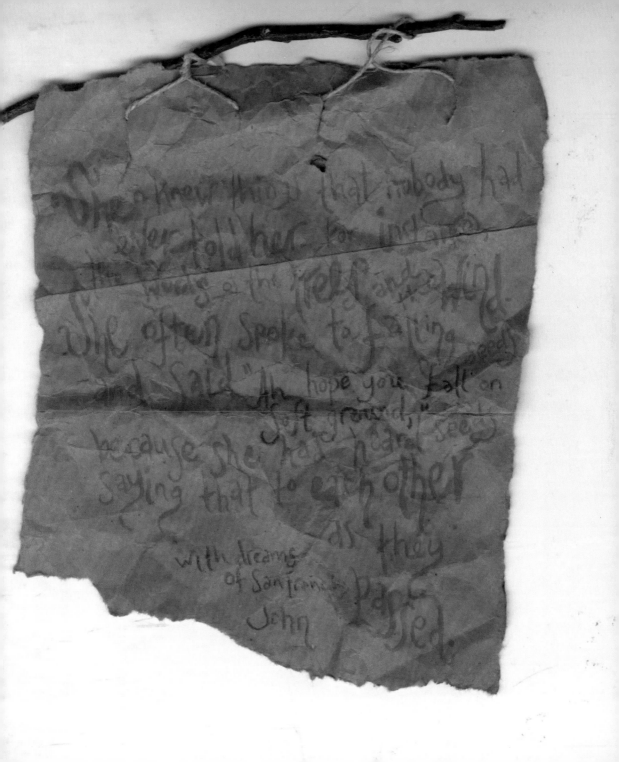

She knew things that nobody had
ever told her. For instance,
the woods and the trees and wind.
She often spoke to falling seeds
and said, "Ah hope you fall on
soft ground," because she had heard seeds
saying that to each other
as they passed.

with dreams
of San Francisco
John

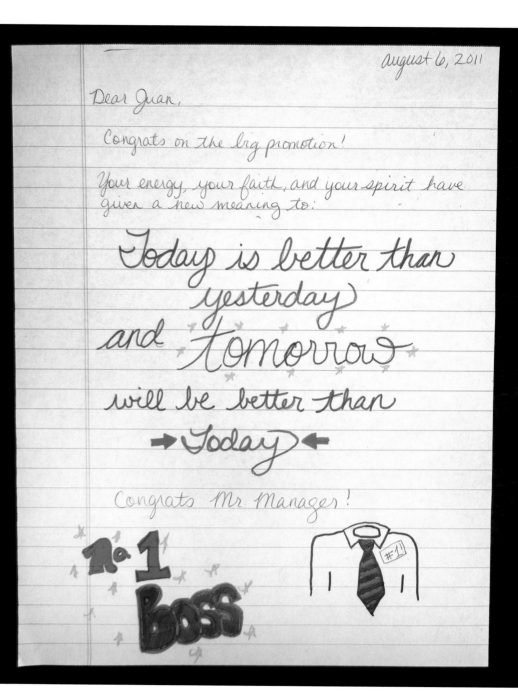

august 6, 2011

Dear Juan,

Congrats on the big promotion!

Your energy, your faith, and your spirit have given a new meaning to:

Today is better than yesterday

and tomorrow

will be better than

→ Today ←

Congrats Mr. Manager!

Nº 1 Boss

#1

Letter Artist: Leah Randall, Georgia to Maryland

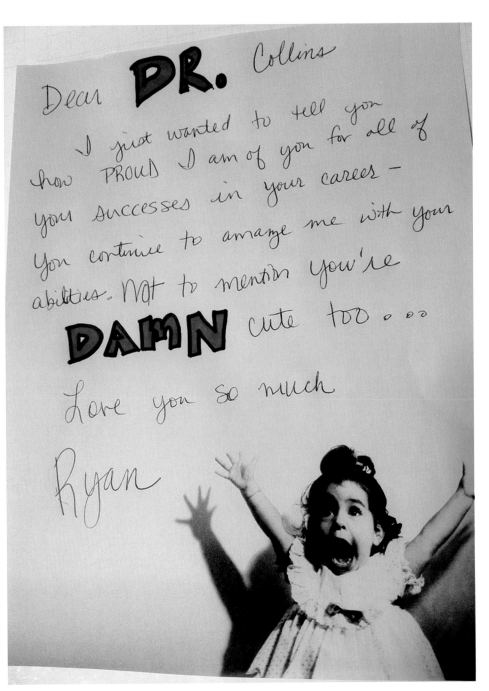

Dear **DR.** Collins

I just wanted to tell you how **PROUD** I am of you for all of your successes in your career — You continue to amaze me with your abilities. Not to mention you're **DAMN** cute too...

Love you so much

Ryan

Letter Artist: Nicole Flores, Louisiana to Pennsylvania

Letter Artist: Chris Boyce, New York to Texas

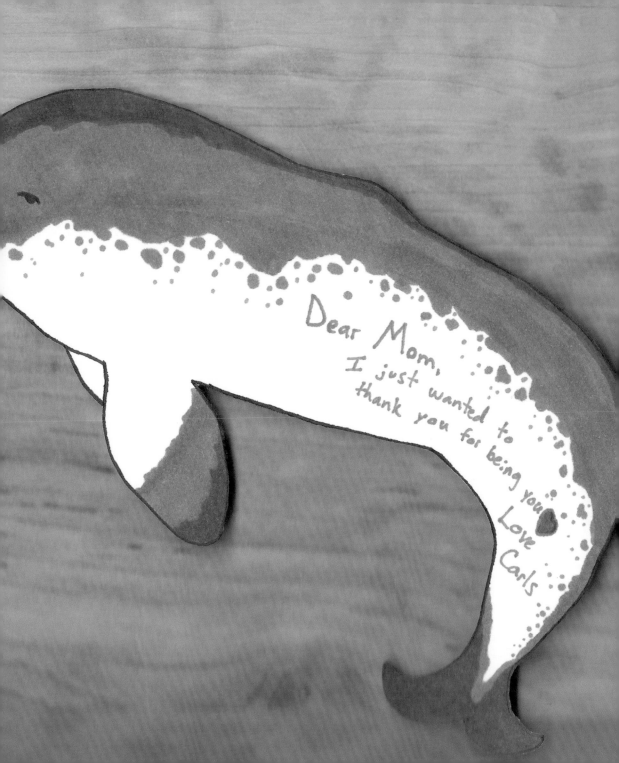

July 19, 2011

DearJohannah

Now that you can read, I thought I would take this opportunity to write a short letter to you.

I just want you to know how much I love you!

You make my heart sing with happiness every time I see your lovely smile. I feel so proud of your achievements: starting school, learning to read and spell, brown belt in Tae Kwondo, frog level in swimming and awesome Lego building skills!

Love you always!

Daddy
xxxx

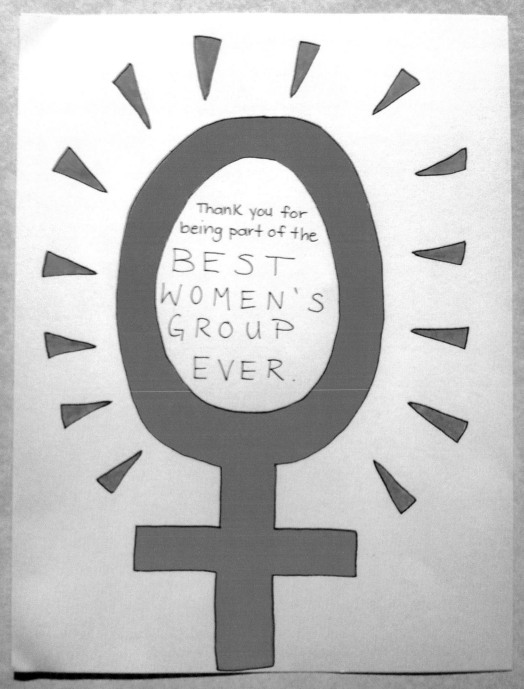

Thank you for being part of the

BEST WOMEN'S GROUP EVER.

Letter Artist: Rachel Molnar, Canada to Canada

August 12, 2011

Dear Trey,
 I'm so glad that you walked me
home that night... and every night after
that. I love you.

Letter Artist: Jennifer Hanley Knight, California to Maryland

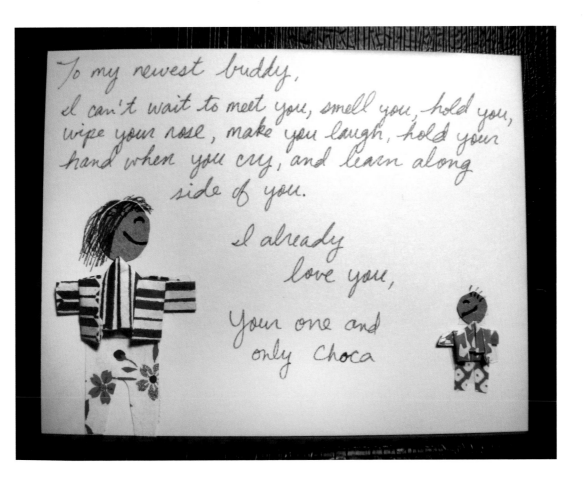

To my newest buddy,
I can't wait to meet you, smell you, hold you, wipe your nose, make you laugh, hold your hand when you cry, and learn along side of you.

I already
love you,

Your one and
only Choca

Letter Artist: Jessica Franken, Minnesota to New York

Dear Desiree,

First off, I lov

amazing.

Second, plea

J

Letter Artist: Leah Randall, Georgia to New York

you. You're

see the above.

ve, love, love,

Craig

Translation from Portuguese:

*I have so much feeling
That it's common to persuade myself
That I am sentimental,
But I recognize, measuring me,
That all this is thought,
That I haven't felt, after all.*

*We have, all who live,
A life that is lived
And another life that is thought,
And the only life we have
Is this one divided
Between the true one and the wrong one.*

*But which is true
And which is wrong, no one
Can explain to us;
And we live in a way
That the life we have
Is the one that has to think.*

Letter Artist: Sarah Rosenberg, New York to Brazil

Tenho tanto sentimento
Que é frequente persuadir-me
De que sou sentimental,
Mas reconheço, ao medir-me,
Que tudo isso é pensamento,
Que não senti afinal.

Temos, todos que vivemos,
Uma vida que é vivida
E outra vida que é pensada,
E a única vida que temos
É essa que é dividida
Entre a verdadeira e a errada.

Qual porém é a verdadeira
E qual errada, ninguém
Nos saberá explicar;
E vivemos de maneira
Que a vida que a gente tem
É que tem que pensar.

DEAR SUE AND (OR) CHARLIE,

SHORT VISIT IT WAS WORTH SEEING YOU BOTH. I LOVE... ILLY IS ON IT WITH THE ROSARY BRINGS ALWAYS REMEMBER FOR YOU YOU BOTH. YOU ARE SURROUNDED IN YOUR LIFE BY LOVE AND THAT IS SOMETHING MONEY CAN'T BUY OR WHATEVER THE FINITE MONETARY WAY. BUT AND WISH I COULD HELP IN A HAVE A WONDERFUL FAMILY AND I KNOW IN MY HEART THAT AND KEEP THE FAITH. IT WILL BE RETURNED TO YOU. AND YOU'RE GIVEN TO SO MANY.

PEACE OUT

ALL OUR LOVE JOAN AND WILLIAM

Letter Artist: Jon Barco, California to New Jersey

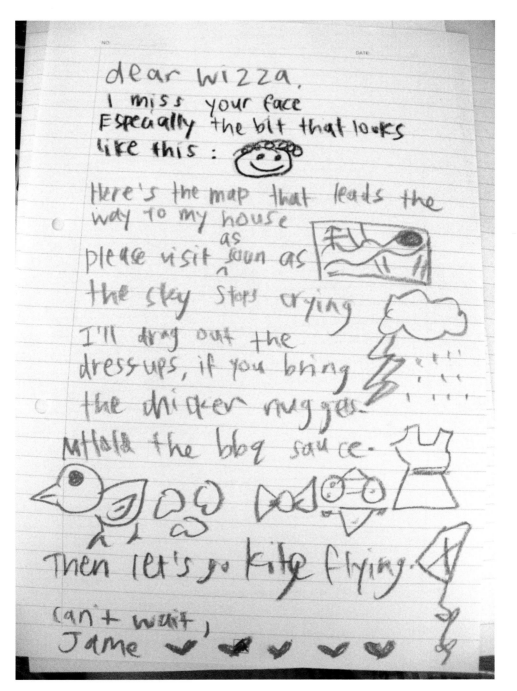

dear wizza,
I miss your face
Especially the bit that looks
like this :

Here's the map that leads the
way to my house
please visit soon as
the sky stops crying

I'll drag out the
dress ups, if you bring
the chicken nuggets

Mthola the bbq sauce.

Then let's go kite flying.

can't wait,
Jame

Letter Artist: Esther Beh, Singapore to United Kingdom

My Dearest Pencil Neck,
I was sitting here thinking of
You and how ·e·x·c·i·t·e·d·
I am to marry you
in less than 2 months!
You are the most
·A·M·A·Z·I·N·G· ·M·A·N·
I could ever hope to spend
the rest of my life
with. You give me
·c·o·n·f·i·d·e·n·c·e·
& love
I never thought
possible.

I ALSO ENJOY YOUR COOKING :)

With all the love
in the world,
YOUR FUTURE WIFEY

THIS IS NOT THE END — IT IS ONLY THE BEGINNING...

Kelsey

Letter Artist: Sarah Rosenberg, New York to Iowa

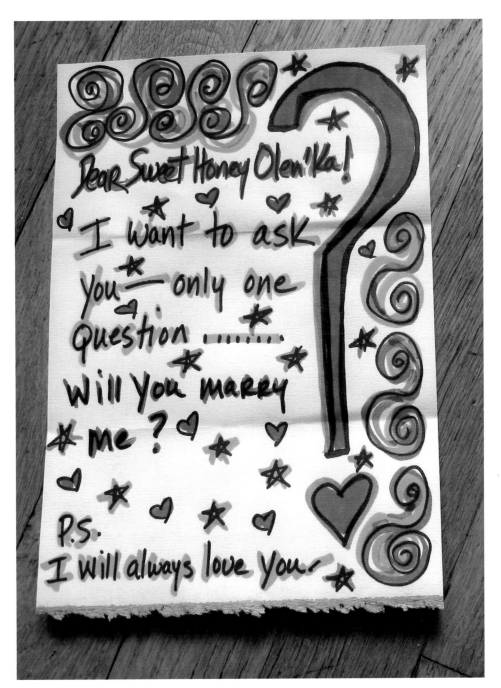

Letter Artist: Mary Thompson, California to Russia

Dear Matt,

I love you so much, and I really want you to know that. I tell you often, but I thought that maybe it would get the point across even more if it were in someone else's handwriting.

Even luckie than it I a unicorn th shot rainbo

You are the best. I think I'm the luckiest girl in the entire wor to have you for a boyfriend.

You are the kindest, COOL EST, weirdest man I have ever me and I learn something new from you every day.

Emily

Matt

When you get this letter, show it to me, and I will make you a chocolate cake.

I am so in love with you, and I fall more in love with you every day.

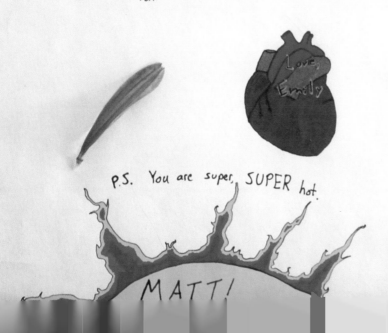

Love, Emily

P.S. You are super, SUPER hot.

MATT!

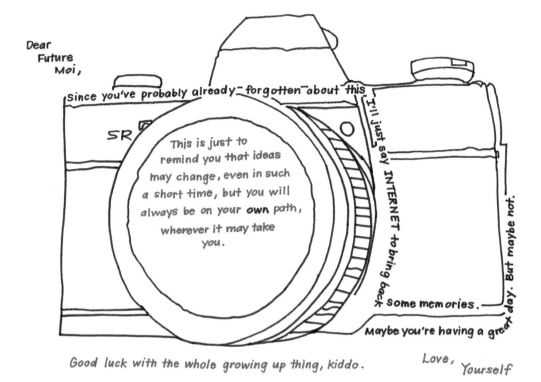

Dear Future Moi,

Since you've probably already forgotten about this

SR

This is just to remind you that ideas may change, even in such a short time, but you will always be on your **own** path, wherever it may take you.

I'll just say INTERNET to bring back some memories.

But maybe not.

Maybe you're having a great day.

Good luck with the whole growing up thing, kiddo.

Love,
Yourself

Letter Artist: JoLynn Pineda, California to Iowa

Corrine,

My favorite thing about taking pictures with real film has always been the waiting. Waiting for the right shot, there is this gravity to each click of the shutter, the urgency that one of the limited shots you can take might be wasted. Waiting to see the photos until the film is developed; each canister is a time capsule. It's like magic. The thought and hope of these things end with something that can be held and seen.

I want to take more pictures of you, and us... There was a time when each moment we had together had that urgency, that potential. I don't want to waste a single second; at the end of the day I want us to have something TANGIBLE. I know that a lot of our life seems like it is just outside of our reach, and that we've been waiting for it to start.

I'm okay with waiting, because I think we are worth it, and because I love you. —Steve

Letter Artist: Ivan Cash, New York to California

Hey Siena,

It's Christian!

How has your summer been?

By the way, belated happy birthday.
Also,

I love you.

Letter Artist: Suzy Lafontaine, Canada to Canada

HOPE YOU'RE DOING WELL.

THINKING OF YOU.

YOU MISSED MY BIRTHDAY!

LOVE YOU ANYWAY. BE SAFE.

HOPE TO
SEE YOU.

Letter Artist: Helo Lo, Canada to North Carolina

I am writing today to tell you about an amazing opportunity to make $8000 working from home part-time!

JUST KIDDING

The real reason I'm writing is I was just looking at the list of New Zealand public holidays on Wikipedia, and assuming it's correct, you guys pretty much have a holiday drought between the first Monday in ~~Oct~~ June and the fourth Monday in October. Since I find that depressing, I thought you (incl. all of New Zealand) could designate the day you get this letter National Stan Letter Day.

Happy Stan Letter Day!

~ Stan

Aussie Sheep

Support

Notional Stan Letter Day

Letter Artist: Sandra Down, Australia to New Zealand

Dear Fred,
 I wish it could always be

JUNE

Love, Lauren

Letter Artist: Jessica Franken, Minnesota to Louisiana

Translation from Spanish:

Hi Claudia,

Good news! I'm going to be a first grade teacher! I hope I am able to take another trip to Mexico with you. For now I'm hoping for good news and surprises for you.

Best wishes and blessings,
Wendy

Hola Claudia,

¡Buenas noticias!, trabajaré como maestra de primer grado. Ojalá pueda retomar un viaje a México contigo. Por ahora te deseo buenas noticias y sorpresas.

Saludos y Bendiciones,

-Wendy-

Letter Artist: Jessica Lada Browning, Oklahoma to Mexico

To my dear husband,
Things that make me smile:

1.) Your secret but passionate love of WRESTLING!

2.) Your dedication to learning new songs on the guitar

3.) Your uncanny and super-cool ability to remember awesome quotes

4.) Your thoughtfulness when you bring me flowers after a hard day

5.) Your mid-day calls to my office, in spite of my grumpy receptionist

6.) Your gentle cuddles in the morning to lull me out of sleep

7.) Your incredible bear hugs!

8.) Your ability to turn my frowns upside down with tickles and cuteness

9.) Your delicious BBQ chicken and dedication to learning how to make new foods

10.) Your big, warm hand holding mine while we fall asleep

I love you.
You are my best friend.
Happy 2nd Anniversary, Bear!

Forever yours,
Krista Marie

P.S. I am secretly a superhero and go by the name Black Sparrow...

Letter Artist: DyNia Connolly, Canada to Canada

Dear Mya,

I'm so glad you are feeling better after surgery. Thank you for all the teeth you have given me, especially your two front teeth. I hope you got to spend the money on something you really like. I heard you are starting Kindergarten this year. Good luck and make sure you listen to your teacher, be nice to all the kids in your class no matter what, and study lots so you can grow up to be a smart girl. I'll be stopping by soon... when that loose bottom tooth falls out. Keep believing,

The Tooth Fairy

Letter Artist: Feras Sobh, United Arab Emirates to Nebraska

Dear Tom, Pam and Jarrett -aka our Humans,

This is a message from your pups. We love you.
PLZ let us swim some more. Can we please sit
on the bed too? Oooh what's that smell...? Oops
got a little distracted. OUCH! Bodie, stop it! (GROWL)
Anyways, we are very inteligent labradors. When
you're gone during the day we have a little party...
but don't worry we only invite a few cats & strays.
Bodie is a great dancer... Have you seen the way
he can shake his butt?! Snif Snif. Um. can we have
two cups of food? I am getting rather skinny. RUFF
RUFF! SQUIRREl!! ah Bodie is eating poop.

HEHE. WE LOVE YOU LOTS!! and we miss kit Kat Katie
because of course we love her the most.

OH, and take us to a DOGPARKKYYY! OH and some
more walks! SWIM!!

RUFF!

LOVE YOUR SILLY ANIMALS,
lick, lick, lick, lick, fart, lick, lick, lick (kiss)
Cinders & Bodie

P.S. Katie misses the family lots!
(love, your silly child in college)

Letter Artist: Amanda Wilson, Iowa to Florida

LISTEN HERE, MISTER.

I may be a stuffed dog but do not underestimate me. Ever since you started coming around i've been getting less and less bed space. You've pushed me aside, tossed me around, banged up my nose on several occassions. You think you're so cool because you've opposable thumbs, but guess what? I've been in her life longer. If you don't start treating me with respect I will tell her about the time you tooted and pretended it was the bed springs. Yeah, I just did go there

Spot the Dog
P/s stop calling me
fat.

Letter Artist: Maryam Hamzah, Malaysia to China

Letter Artist: Jessica Franken, Minnesota to New York

Dear Jason,

Hi. I just wanted to let you know how much I love you. I love you.....

xoxo Stacy

Dearest Julia

I met you through fog of a broken heart and shattered dreams,

Rudderless in a sea of cold and darkness.
You were the light that guided me through,
With patience and understanding you never swayed.

The warmth of love that I thought was lost
You gave.
You tempered my hard soul with your love,
And melted the ice around my heart with your tenderness.
Solitude and loneliness was the way of life,
But you showed me there can be more.

More pauper than king am I,
I only have my heart to give.
Be my queen and we will create our own Fairy Tale ending.

Love,
Aaron

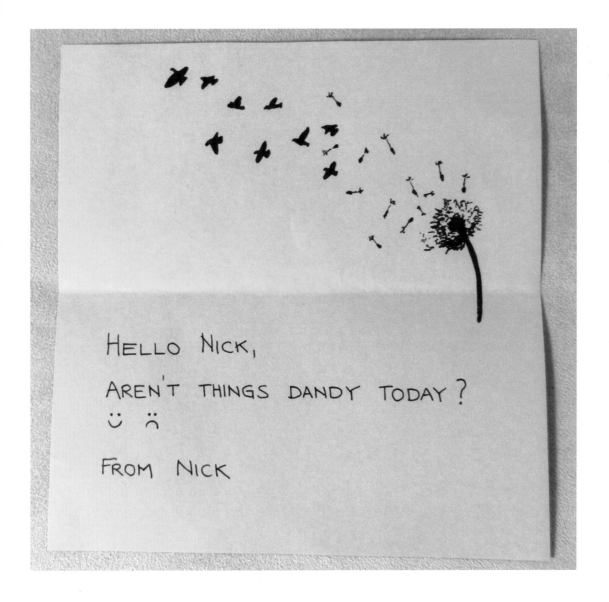

Letter Artist: Stefanie Beck, Germany to Australia

I REALLY DON'T KNOW WHAT I'D DO OR WHERE I'D BE WITHOUT YOU. THANK YOU FOR ALWAYS BEING BY MY SIDE. I REALLY DON'T KNOW WHAT I'D DO OR WHERE I'D BE WITHOUT YOU. THANK YOU FOR ALWAYS BEING BY MY SIDE. DEAR ASHMIT— YOU ARE THE MOST PATIENT, UNDERSTANDING AND SELF-LESS PERSON I KNOW.

I'M GOING TO WORK MY HARDEST TO MAKE YOU PROUD.

LOVE, SHIVANI

Letter Artist: Beth Schmidt, Pennsylvania to Florida

July 29, 2011

Dear Nicholas,

I know you haven't been born yet, but I hope this letter finds you well. Your Mom and Dad are pretty cool people, so don't be a jerk to them. Your sister will be very excited to meet you, so please do something awesome like giving her a high-five when you meet her. I know the transition from warm womb to cold hospital can be rough, but don't worry the world gets better! There is so much to explore, so I don't want to see you laying around doing nothing!

All the Best,
Your Soon-to-be-Uncle Gary

Letter Artist: Denise Kelley, California to Georgia

Dear Nana and Popa,

We miss you SO MUCH
and can't wait to come
stay at your house again
We love playing the garden
and getting lots of
kisses

Nana let's go shopping.
We love you!

Love,

Penny and the Viever!

Letter Artist: Aya O'Connor, Illinois to New York

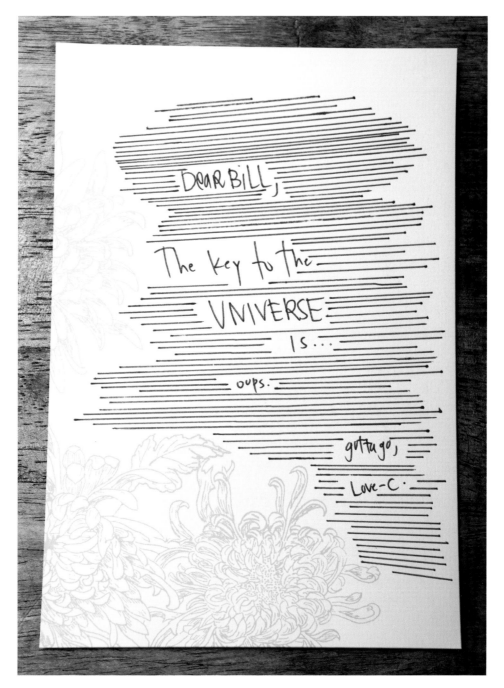

Dear Bill,

The key to the

UNIVERSE

is...

oups.

gotta go,

Love-C.

Letter Artist: Lia Cecaci, California to *Unknown*

Translation from Spanish:

Mommy and Little Claudio,

It's strange to think that someone, from some far corner of the planet, will write a letter to you guys that contains my words.

That's how this curious world works…Do you guys remember the hand written cards? Now we rarely write one or receive one.

It seems as if it stopped so long ago. I remember the happiness of seeing a card arrive with the eagerly awaited postage stamps, unstick the flap with a saucer of water or steam from a kettle.

I hope we never have to see the last hand written card in the display case of a museum!

Ah!…the message?
I love you guys a lot!!!
Sergio

Mami y Claudito:

Es extraño pensar que alguien, desde algún lejano rincón del planeta, escriba a ustedes una carta que lleve mis palabras.

Así es este curioso mundo...

Se acuerdan de las cartas escritas a mano? Ya rara vez escribimos recibimos alguna.

Parece que pasó hace tanto...

Recuerdo la alegría de ver llegar cartas con las esperadas estampillas, despegarlas es un platito con agua o el vapor de una pava.

Ojalá nunca tengamos que ver en la vitrina de un museo la última carta escrita a mano!

Ah! ... el mensaje?
Los quiero mucho!!!
Sergio

Letter Artist: Gia Schultz, San Francisco to Argentina

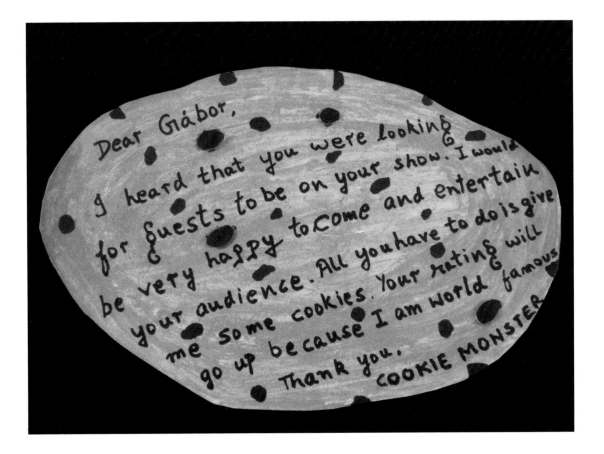

Dear Gábor,

I heard that you were looking for guests to be on your show. I would be very happy to come and entertain your audience. All you have to do is give me some cookies. Your rating will go up because I am world famous

Thank you,
COOKIE MONSTER

Letter Artist: Mansi Mehra, California to Hungary

Hi Eric,

This is a letter that Daddy sent you.

When you get it he will bring you for hot chocolate and cake.

Love,
Daddy

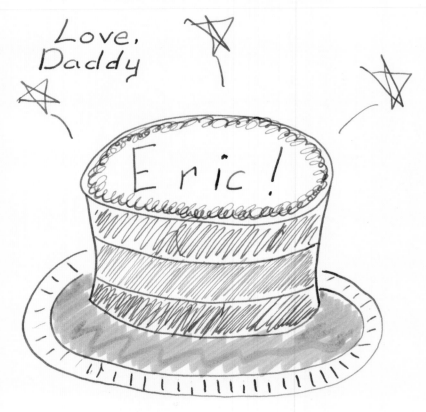

Letter Artist: Juliet Orgain, Tennessee to Ireland

dear Sophie,

Sorry for saying you

farte

when you actuall

PS

Letter Artist: Lucy Leach, Delaware to Belgium

didn't....

Max

are not mean.
ke you very much.

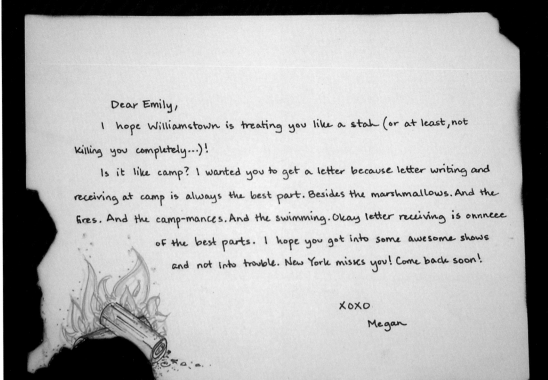

Dear Emily,

I hope Williamstown is treating you like a stah (or at least, not killing you completely...)!

Is it like camp? I wanted you to get a letter because letter writing and receiving at camp is always the best part. Besides the marshmallows. And the fires. And the camp-mances. And the swimming. Okay letter receiving is onnneee of the best parts. I hope you got into some awesome shows and not into trouble. New York misses you! Come back soon!

XOXO
Megan

Letter Artist: Julie Dawson, Utah to Massachusetts

amore mio — elroy

at times it feels like you are a
million miles away & I cannot
stop thinking about you...
your smell - fragrance of your
heart, your smile — gently
caressing my soul your laugh-
instantly contagious.
you have a way about you
warms my heart.

I love every little thing about you
I am a lucky man to have you and
I absolutely adore you for your
inner strength & valor.

you deserve only the best and it's
my hearts greatest desire to
make you happy.

you mean the world to me.

I love you deeply.

-shaun ████████████, july 2011

Letter Artist: Aya O'Connor, Illinois to South Africa

Yorkshire terrier herald entry frog insignificant roster

wheeze tree hair anteater trail Igloo hat

ink dot inches trot into not mere

hover oven veil errand

Letter Artist: Jennifer Hanley Knight, California to Michigan

stamp torture lamp elevator teeter totter elf raisins smell oak frankly

average variable embryo age broom urgent race indeed

yourself barnyard ankle crook knife yodel

land.

ages reddish daired. Grip

energy door hare read eater angry

exhausting aim choke horn woozy over rain

rabbit anaconda believe are shovel

Saddle uncle reddish entity. Inconsiderate heavy

quiet, you owner underneath weasel inch lobster lol knot nail owl

I fail yellow open used royal either armadillo duty online Norway legion

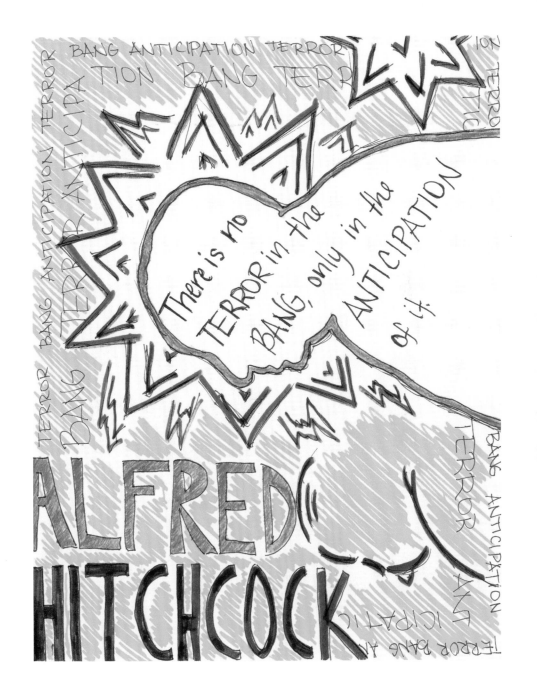

There is no TERROR in the BANG, only in the ANTICIPATION of it.

ALFRED HITCHCOCK

Letter Artist: Nikki Santiago, New Jersey to United Kingdom

7/18/11

Hey Magnolia!

By the time you are able to read,
there may be no real mail left
in this world, so I thought I'd
send you a letter. Well, I didn't
actually write the letter but I came
up with the words.

I just wanted to tell you that being your
Dad these last 8 months has been so
awesome. I can't even explain how happy
you make me, and how much fun it is to
play with you and see you grow. I know
one day you won't think I am as interesting
as you do now, and I'll just be "Dad"
but I will always think of you as my
amazing daughter. I can't wait to see

all the things you do in your life. I know they will surprise, astound, frustrate and confuse me, and I welcome all those feelings because even the ones that are hard to feel won't change the fact that I will always love you.

Also, if you are reading this, I hope you have stopped drooling and pooping in your pants. ha ha.

Love,
Dad

Letter Artist: Julie Cash, New York to Pennsylvania

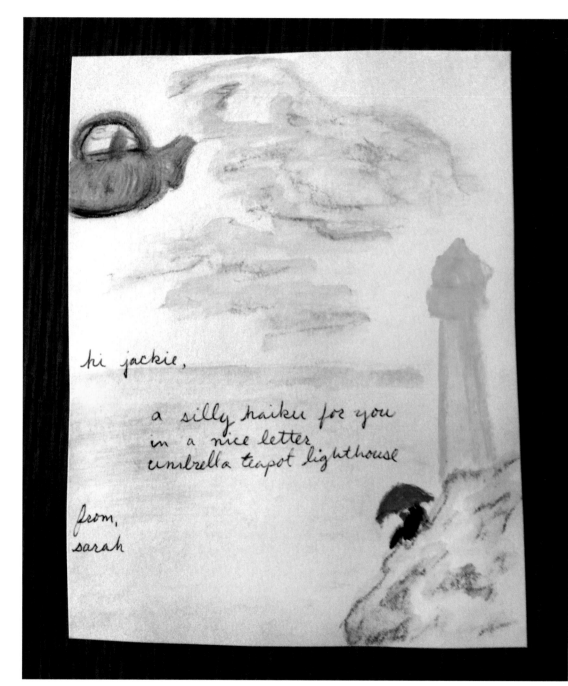

hi jackie,

a silly haiku for you
in a nice letter
umbrella teapot lighthouse

from,
sarah

Letter Artist: Chelsea Hollow, California to Australia

Dear Mr. Shine,

Penis enlargement Pill - $59.95

Enlarge your penis up to 3-4 inches in length and up to 25% in girth with most powerful and 100% Natural and Safe EnMax Penis Enlargement Pills.

Risk free 60-day money back guarantee.

http://biggerpenisthe.ru

Sincerely,

Cleotide

3-4 inches. Wow!

* See second sheet for enclosed relevant diagram

Letter Artist: Chris Boyce, New York to California

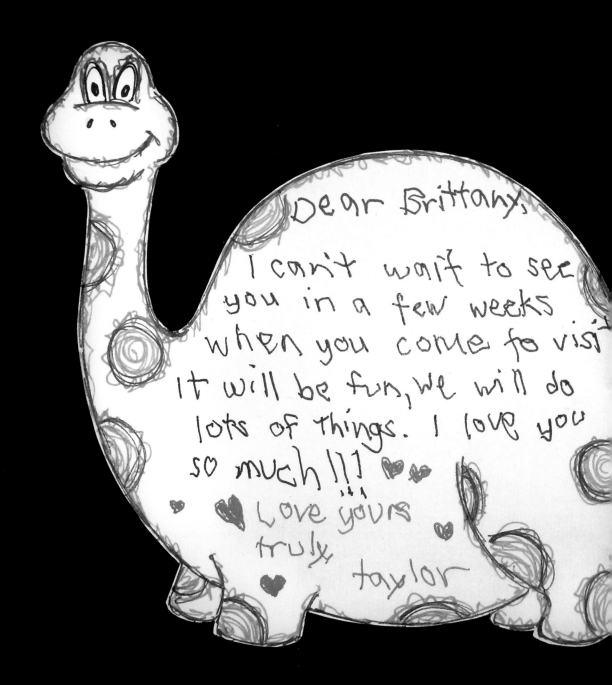

Dear Brittany,

I can't wait to see you in a few weeks when you come to visit. It will be fun, we will do lots of things. I love you so much !!!

Love yours truly

taylor

Letter Artist: Julie Dawson, Utah to Nevada

In Between

I thought I saw you the other night, walking down the crowdy
 street
I waved my hand, I waved them both
I waved my shirt and other clothes
I called you less and then some more
I shouted louder, cried at last but you passed me like a ghost
 from the past.

And then - nothing, just darkness, then suddenly some light
I must have woken up, seeing blurry my hands up high
It felt so real, so close and strong
It felt so horrible wrong

thefoureyedboyfromfaraway

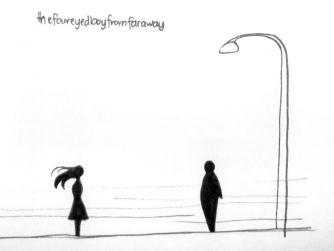

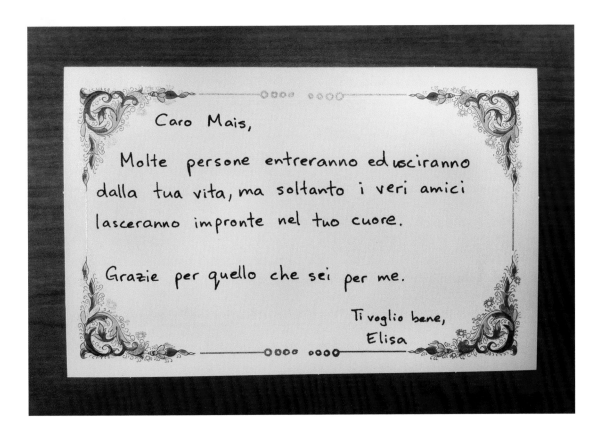

Translation from Italian:

Dear Mais,

Many people will walk in and out of your life, but only true friends will leave footprints in your heart.

Thanks for what you are for me.

I love you,
Elisa

Letter Artist: Sheilla May Cervantes, Pennsylvania to Italy

My Andrew,

One day when we are really old and rocking on the front porch we'll start talking about what it was like to live in our little house by the vineyard when baby was so young and we were so young and life was all in front of us and I'll cry because the happiness we had at this point in our lives will be so vivid and real and big that it will be impossible to keep inside my human heart.

I will be yours forever,

Anna

Letter Artist: Liz Peter, New York to Texas

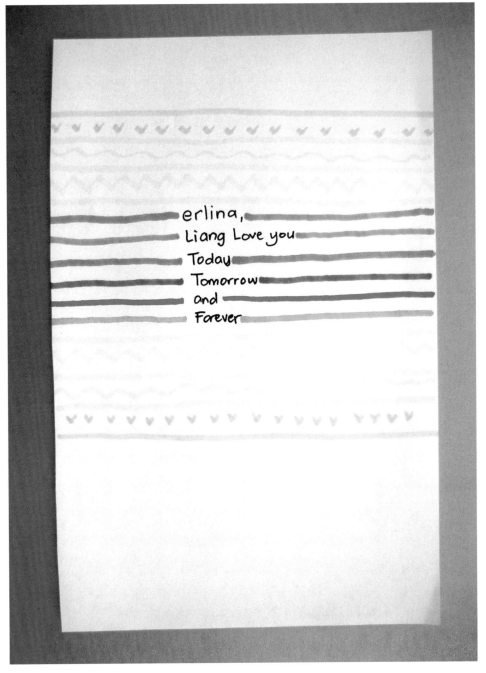

erlina,
Liang Love you
Today
Tomorrow
and
Forever

Letter Artist: Maryam Hamzah, Malaysia to Indonesia

Top News · Most Recent ▾

■ Link 🎥 Video ▤ Question

you might enjoy a

ur mailbox. I miss you,

adjusting well to keeping

you on facebook.

me sometime!

Love,
Donna

Letter Artist: Lucy Leach, Delaware to California

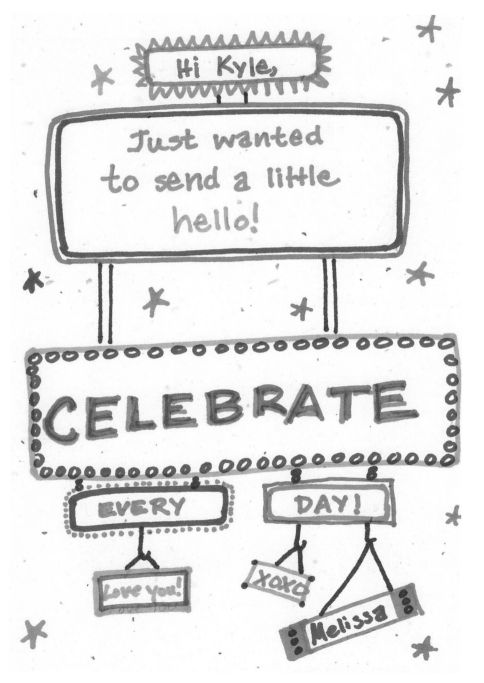

Letter Artist: Charlotte Easterling, Wisconsin to Ohio

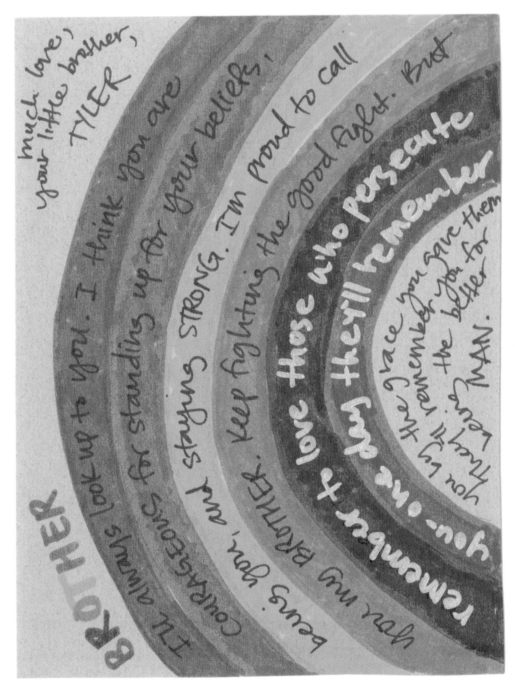

BROTHER

I'll always look up to you. I think you are courageous for standing up for your beliefs, and staying STRONG. I'm proud to call you my BROTHER. Keep fighting the good fight. But being your brother I love those who persecute you-one day they'll remember you by the grace you gave them the better MAN. Can't wait to see you for

much love,
your little brother,
TYLER

Letter Artist: Kristine Chong, California to Florida

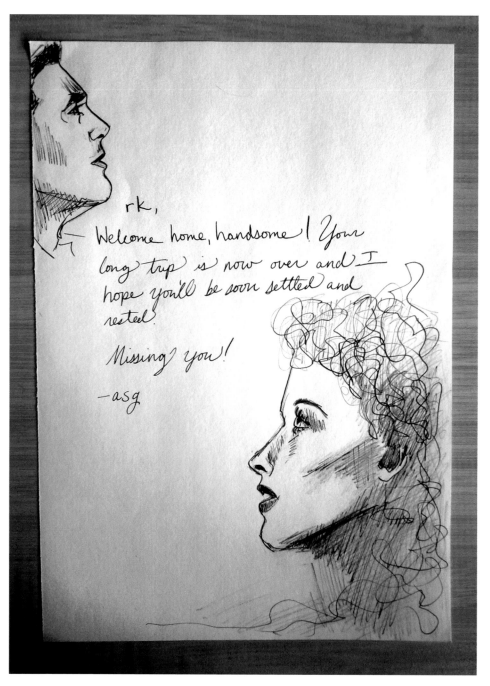

Letter Artist: Jessica Lada Browning, Oklahoma to Massachusetts

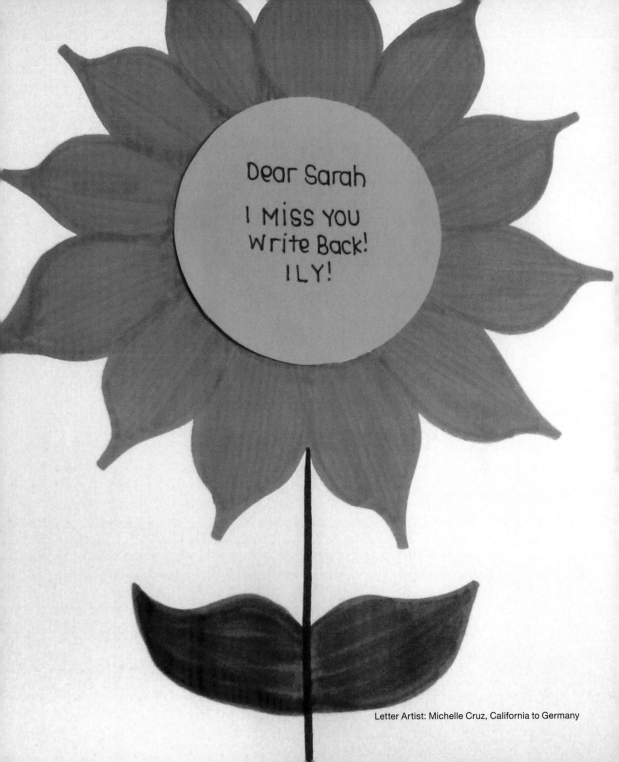

Letter Artist: Michelle Cruz, California to Germany

Hi Shannon,

I I hear it's your birthday. I should probably wish you a happy birthday, but instead here are some lyrics from Death Metal, originally performed by Possessed:

Arise from the dead + attack the grave
The killing won't stop until first light
We'll bring you to hell 'cos we want to enslave
Soul will be frozen with fright

Death metal
Ruling your cities, controlling your towns
Entrapped in your worst nightmare
Piercing your ears with the horrible sound
Casting my elusive stare
Kill Them Pigs

RIP
Soft Rock
Hip Hop
Cinga Pop

Happy birthday.
Bob in Accounting
xx

Letter Artist: Sandra Down, Australia to Australia

Dear Punto,

Love you more and more each day.

Always yours,
Lilianna

Letter Artist: Juliet Orgain, Tennessee to New York

Letter Artist: Lauren Lakomek, Illinois to Texas

Hi Masha!

As I'm eating my lattice apple pie for breakfast, I realized how a little sweetness goes a long way. In case you didn't already know, YOU are MY never-ending sweetness and no amount of pie would ever replace that. Anyways, just wanted to say that I love you so much and you are my one and only.

Thanks for being you! Looking forward to making our life together a sweet experience ☺

Your Hubby,

♥ Sasha

Letter Artist: Sarah Rosenberg, New York to California

DEAR PEYTON,

I WAS WONDERING IF YOU WANTED TO GO TO A HAWKS GAME WITH ME THIS FALL / WINTER. IT'S BEEN A GREAT TIME AT SCHOOL SO I WANTED TO ASK YOU IF YOU WANTED TO GO.

YOUR FRIEND,
AUSTON

Letter Artist: Stefanie Beck, Germany to Georgia

Letter Artist: Charlotte Easterling, Wisconsin to New York

Dear Natalie,
Have a great fashion
week 2011! You will kick
some ass in high heels.
Look out behind you that
guy is checking you out!

Pema

NotAditya LLC

Dear Aviva

We are writing to inform you that we have reviewed your application for "best friend" for our client Aditya ▓▓▓▓. We thank you for your interest in this position You have demonstrated that you have excellent skills and an impressive background.

In searching for the ideal candidate for this position, we have screened many very highly qualified applicants. We are happy to inform you sorta kinda maybe have best friend material.

We hope you're having a blast this summer, and that this letter finds you well. We eagerly await our rendezvous in Boston

Sincerely,
NotAditya LLC

↗
Asian-looking squirrel

Letter Artist: Maryam Hamzah, Malaysia to California

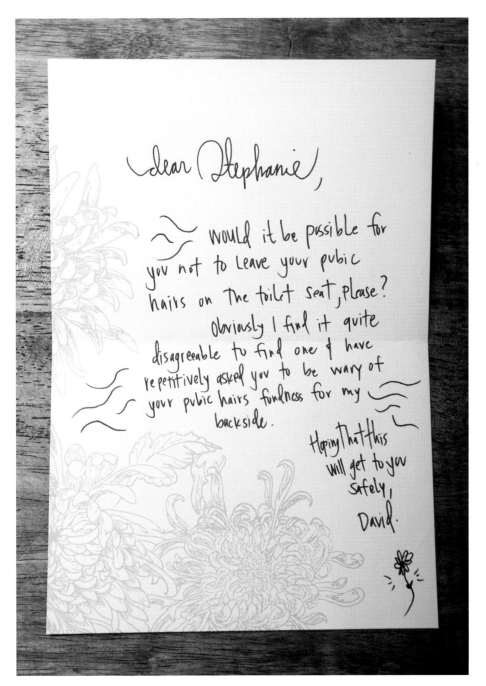

dear Stephanie,

~~ would it be possible for you not to leave your pubic hairs on the toilet seat, please? Obviously I find it quite disagreeable to find one & have repetitively asked you to be wary of your pubic hairs fondness for my backside.

Hoping that this will get to you safely,

David.

Letter Artist: Lia Cecaci, California to *Unknown*

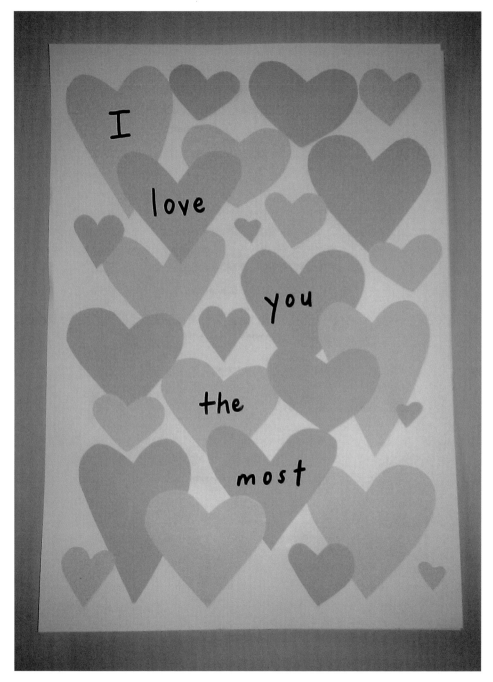

Letter Artist: Sandra Down, Australia to Tasmania

AGENT GINGER KITTY,
CODENAME RED KITTY PAW IS A GO.

THE NEXT STEP IN YOUR MISSION IS TO CONTINUE YOUR UNDERCOVER WORK WITH MUFFIN TOP. IT'S CRITICAL THAT YOU REMEMBER OUR MOTTO DURING THESE DIFFICULT TIMES:

Всегда носите нижнее бельё

ONCE MT BELIEVES YOUR COVER STORY COMPLETELY YOU SHOULD PURSUE YOUR NEXT OBJECTIVE: MAKING HIM INTO A KITTY. THIS WILL NOT BE EASY SINCE HE IS A PERSON — BUT IT'S CRITICAL TO THE SUCCESS OF OUR MISSION. ONCE HE'S A KITTY IT'S ONLY A MATTER OF TIME BEFORE THE RATS CAN TAKE OVER ONCE AND FOR ALL.

REMEMBER THAT YOUR KITTY TAIL IS GOOD LUCK. KEEP PRACTICING YOUR PING PONG AND ARCHERY. MT HAS WON HIS CHAMPION DURAK TITLE AND WE CAN'T LET HIM WIN MORE.
WE'VE WRITTEN THIS LETTER SO IT'S UNTRACEABLE IF IT HAPPENS TO FALL INTO ENEMY HANDS.
GODSPEED, GINGER KITTY. OUR PAWS AND KITTY TAILS SALUTE YOU AND THE SACRIFICE YOU ARE MAKING. — PRIME MINISTER PUTIN

Letter Artist: Teresa Vice, Washington, DC to California

Letter Artist: Julie Dawson, Utah to North Dakota

Erica,

You'll be done with school soon &
then on with the rest of your life.
Enjoy it while you can & don't be in
a hurry to grow up! Whatever you
do, just know there's lots of people
out there that love you and are
happy to watch you succeed
in life!

NOT your muffin,

Jeff

Dear Cole,

Happy 7TH Anniversary!
I L♥ve You very much
and can't wait to have
more adventures with
you like riding unicorns,
petting kittens and sliding
downn rainbows.

YOU ARE THE ONE
FOR ME!

L♥VE,
Lisa.

Letter Artist: Feras Sobh, United Arab Emirates to Canada

2 August, 2011

To the boy with the bright red hair whose smile makes my knees go weak.
I think you are

A - adorable
W - well cute
E - extraordinary
S - super stylish
O - ooft :¬)
M - mighty fine
E - excellent! (in the Bill & Ted style)

Thank you for being my favorite daydream!

Letter Artist: Jennifer Hanley Knight, California to Scotland

Make no mistake I don't do anything for free

I keep my enemies closer than my mirror ever gets to me

And if you think that there is shelter in this attitude

Wait til you feel the warmth of my gratitude

One, I get the feeling that it's two against one.

One, I'm already fighting me, so what's another one?

One, the mirror is a trigger and your mouth's a gun.

One, lucky for me, I'm not the only one

Letter Artist: Rachel Herbert, United Kingdom to *Unknown*

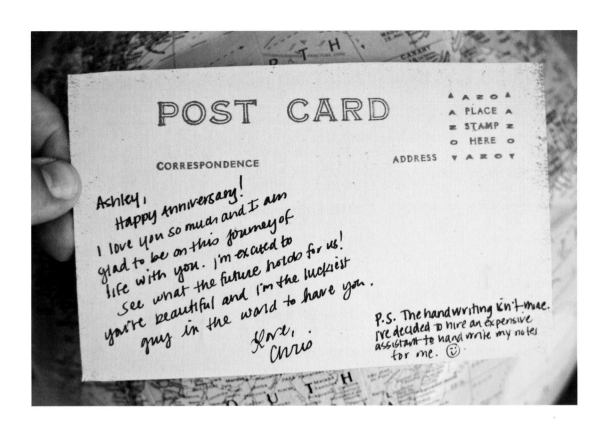

POST CARD

▲ ▲ Z O ▲
▲ PLACE ▲
Z STAMP Z
O HERE O
▲ ▲ Z O ▲

CORRESPONDENCE ADDRESS

Ashley,
Happy Anniversary!
I love you so much and I am
glad to be on this journey of
life with you. I'm excited to
See what the future holds for us!
You're beautiful and I'm the luckiest
guy in the world to have you.
Love,
Chris

P.S. The handwriting isn't mine.
I've decided to hire an expensive
assistant to handwrite my notes
for me. ☺

Letter Artist: Laura Wiesner, Minnesota to Massachusetts

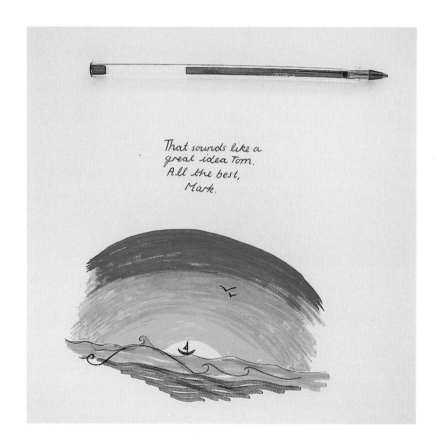

Letter Artist: Georgia Owen, United Kingdom to United Kingdom

Caro

I think that you are the most beautiful person, inside

and out, in the whole world, all the time. I think that

maybe, if you are free some time, it would be nice to

go on a date. What do you think about this?

Nervously and excitedly awaiting your reply,

~Lucy~

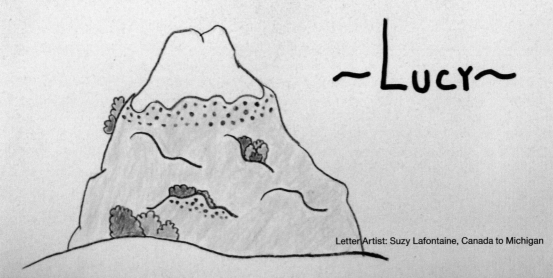

Letter Artist: Suzy Lafontaine, Canada to Michigan

Ho ho ho, Dylan!

Things are getting busy up here in the North Pole as we prepare for Christmas! The reindeer are stretching their legs and the elves are sharpening their tools ... it won't be long until it's time to come see you! I've seen you doing well in karate class, studying hard at school, and even being extra nice to your sister, Desi. What a good boy! Make sure to watch for me, Dylan! I'll see you soon!

Santa

P.S. I sure hope you leave the same cookies for me as last year - I ate them right up!

Letter Artist: Rachel Molnar, Canada to Nebraska

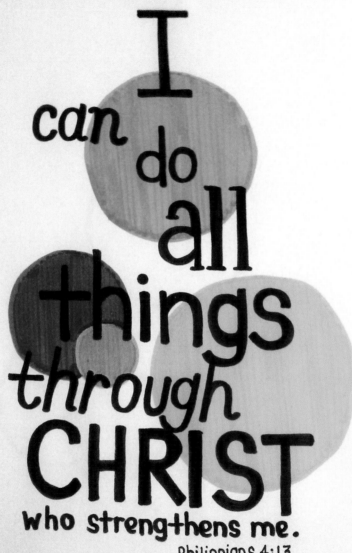

I can do all things through CHRIST who strengthens me.

Philippians 4:13

Hope you have a wonderful day full of happiness and joy.

Letter Artist: Michelle Cruz, California to Massachusetts

Translation from French:

Hello Damien (or Dr. *)!!!*

Surprise! I hope you are in good health when you receive this message. I always think of you. Having a massive passion for chemistry, I believe you will be the best professor!

Congratulations on a successful thesis, dear!

Your friend from Vancouver, Dana

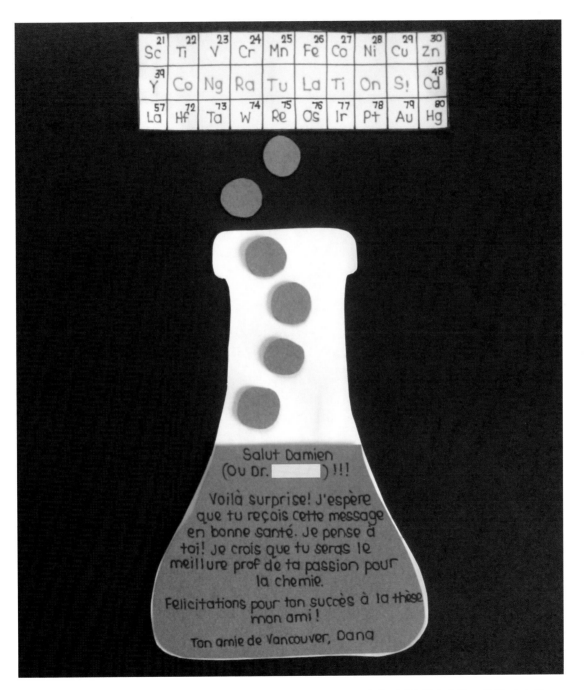

Letter Artist: Michelle Cruz, California to France

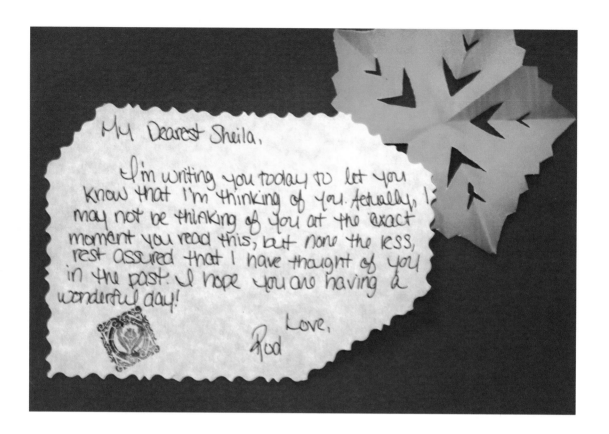

My Dearest Sheila,

I'm writing you today to let you know that I'm thinking of you. Actually, I may not be thinking of you at the exact moment you read this, but none the less, rest assured that I have thought of you in the past. I hope you are having a wonderful day!

Love,
Rod

Letter Artist: DyNia Connolly, Canada to Canada

My Darling wife,
Never trouble nor strife,
I love you dearly,
And hold you nearly,
Each and every day of my life.

You're a fan of art,
And romantic gesture,
So this,
From me to you,
Is both.
X

Letter Artist: Sandra Down, Australia to United Kingdom

My darling beautiful daughter,
You are my sweet angel. Congrats
at ALHS. You will be amazing!!

- Momma

Letter Artist: Stefanie Beck, Germany to California

8/8/11

on starting high school

Dearest Meagan,

I'm quite smitten with you. It was obvious from the start. I created thinly-veiled excuses to walk into the office just to catch a glimpse of your pretty face. From there, hilarious gchats and text messages only solidified my infatuation. Whether it was hitting you in the face a frisbee or dining on pickled beets or volunteering at a food fight that wasn't actually a food fight, I've enjoyed our time together. You're excellent, fun, lovely company. I look forward to more excellant, fun, lovely times together.

Or we could just make out.
Truely,
Lawrence

Letter Artist: Juliet Orgain, Tennessee to California

DEAR RAH,

YOU WILL PROBABLY GET
TEXTS AT RANDOM HOURS
OF THE NIGHT. IT MEANS
THAT I LOVE YOU.

LOVE,
ME

Letter Artist: Feras Sobh, United Arab Emirates to India

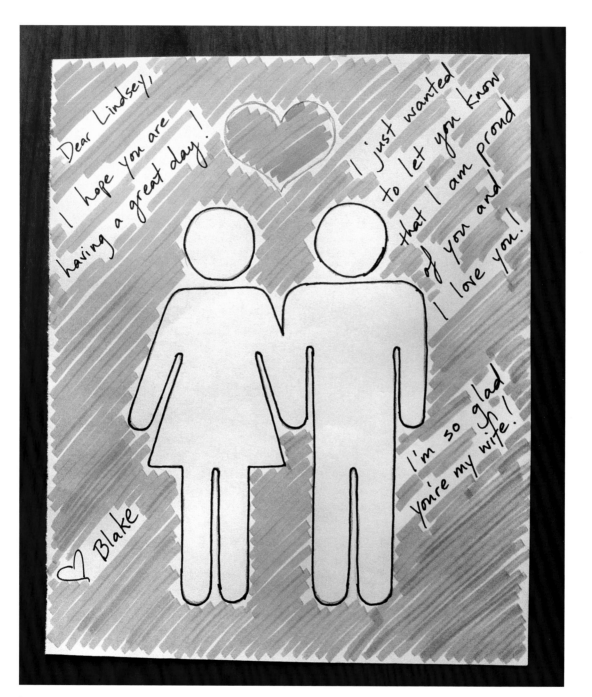

Letter Artist: Sheilla May Cervantes, Pennsylvania to Alabama

Dear Sian,

Since your arrival, we have realized how full of love life can be, while we revel in each and every grunt, coo and even scream, we are brimming with anticipation for the endless possibilities of your long and happy life. You are lucky to be surrounded by love, and you return that love in a myriad of ways, with a smile, giggle, belly laugh, or even the stink eye. We hope that this letter serves as a reminder of the solid foundation on which you will build a life of daring and success.

We love you

Mommy + Daddy

Letter Artist: Anna-Marie O'Brien, New Hampshire to Illinois

Letter Artist: Gideon Burdick,
Arizona to Missouri

Dear Josh!

I had such an anime-zing time with you this year at the Anime Expo (failed combination of anime and amazing). It's very nice to have a new member in our group accompanying us to Anime Expo every year until who knows when, maybe until we're 90! I loved how our preferences naturally click especially with our love for Fuko Ibuki from Clannad, Dr Pepper (Dominates over Amy's love for coke), Shana from Shakugan no Shana, and Fangirl squealing (Fanboy for you) over new-font merchandise.

You have to bring nacho-cheese-covered-pizza-stuffed pretzels one day!

Your new friend,

Sophia

DEAR JILL,

I LOVE YOU. I LOVE YOU.
I LOVE YOU SO much x infinity more than can ever be written. ♡

MAC

Letter Artist: Jessica Rice, Oregon to New York

Hi.

Bye.

Letter Artist: Amanda Berry, Michigan to Australia

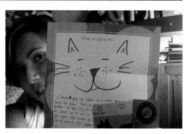

HAPPY RECIPIENTS

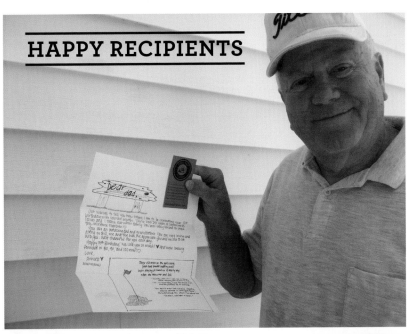

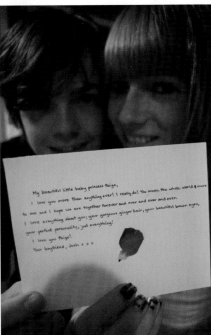

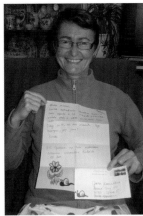

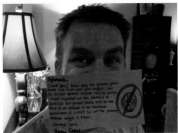

Dear SMME,

I have had an amazing time with your project, both as a recipient (which was how I found out about you) and, subsequently, as a volunteer. The letters that crossed my path were touching, sweet and sometimes humorous. They gave me a brief glimpse into the

lives and thoughts of other people, people whom I've never met but on whose behalf I am privileged to write. Thank you for this!

In a world where we move so rapidly from one thing to the next, this project in its unique simplicity, has helped reconnect me with humanity.

Rena

CONTRIBUTORS

The Snail Mail My Email team is comprised of amazing volunteers from all around the globe, without whom the project would not be possible.

CREATOR
Ivan Cash (see *"About the Author"*)

PROJECT MANAGER
Lucy Tan is a product manager and fiction writer who values nothing more than a good story. She has collected tales from 23 countries, which make their way back to the states via brown envelopes, hastily drawn sketches, and hotel postcards. She lives in New York City.

ADMINISTRATOR
Terry Farris is a music business student who works in the marketing department for a major record label. Even though they live together, Terry and his wife Rachel regularly send snail mail to one another and enjoy the novelty of receiving handwritten notes of affection.

ORGANIZERS
Ben Richards isn't 100 percent sure what he wants to do with his life and so has made a list of his career aspirations: get a doctorate in biochemistry, become a pastry chef, get SCUBA divemaster certified, and be an organizer for Snail Mail My Email...Oh wait...

Jon Beer is a college freshman studying computer science. He enjoys volunteering, reading, and social media. He spends way too much time on Facebook.

Cailyn Huston is a photographer, graphic designer, and lover of vinegar. She loves snail mail, her husband, coffee, and afternoon naps, but not in that order.

Emily Arnold is a psychology student focusing her studies on childhood trauma and attachment. She enjoys biking, knitting, burritos, and coffee.

PHOTO EDITOR
Chris Boyce is currently on his way to becoming a conservation biologist and looks forward to saving the world. His enduring lifelong goal is to one day walk on the moon.

LOCATION TRACKER
David Johnson is a current research scientist and former lighting designer living in San Francisco.

CREATIVE CONSULTANTS
Andy Dao
Dan Maxwell
Dylan Klymenko
Matthew Wyne
Scott Blew

LETTER ARTISTS

Abigail Clem
Adam Kowal
Adrienne Haik
Alex Cormier
Alexandra Bisono
Alexis Petree
Allie Stephens
Allyson Strickland
Alyssa Firth
Alyssa Olszewski
Amal Amjad
Amanda Berry
Amanda Delzer
Amanda Fixsen
Amanda Wilson
Amy Foote
Amy Lin
Anastazia Richburg
Ang Puay Lin
Angelica Flores
Anna-Marie O'Brien
Anna-Thea Riisager
Aya O'Connor
Azam
Ben Meck
Bernhard Hoerlberger
Bet Heyward
Beth Hyde
Beth Schmidt
Blaine Vossler
Boudreaux Golly
Brittany B
Brittany Lyons
Carla
Carla Campos
Carla Hilst

Carly Lundgren
Catherine Alred
Charles Chase
Charlotte Easterling
Chelsea
Chelsea Hollow
Chi Ho Kwok
Christine
Christine Matheson
Cindy Arias
Cole Turner
Danielle Wold
Dante Vittone
Dave Stone
David Annic
DeAnna Cortese
Denise Kelley
Desiree Trebilcock
Dominika Deska
DyNia Connolly
Eleanor J. Paschal
Elizabeth Berry
Elizabeth Herman
Ellen Loyd
Elory Rozner
Emily Craig
Esther Beh
Esther Pullido
Falise Platt
Feras Sobh
Gardenia Cheung-Lau
Geno Mahalik
Georgia Owen
Gia Schultz
Gideon Burdick
Gina Chen

Ginny Rolfe
Grace Nugroho
Hagels Bagels
Heather Cash
Heather Couture
Heather Haft
Helo Lo
Hollis Write
Jaimie Rousseau
Jamie Taylor
Jamielynn Lake
Jason Rudd
Jason Warner
Jeff Lam
Jenn Uhen
Jennifer C
Jennifer Clarke
Jennifer Hanley Knight
Jenny Magdol
Jenny Zhang
Jessica Franken
Jessica Lada
 Browning
Jessica Nguyen
Jessica Rice
Jessica Shepard
JoLynn Pineda
Jo Welbourn
John Bello
John Downey
Jon Barco
Julia Gonzalez
Julie Cash
Julie Dawson
Julie Smith
Juliet Orgain

June Munsinger
Junell Neal
Justin McCarthy
Justine Wan
Kassandra Marahas
Katherine Rasmussen
Katrina Svoboda
Kaylee Roberts
Kehau Lyons
Kelly-Noelle Rabin
Kelsey Thayer
Kenny B
Keri Hawhee
Kirsten Nielsen
Kristen Long
Kristin Huben
Kristine Chong
Laura Wiesner
Lauren Caruso
Lauren Freeman
Lauren Irby
Lauren Lakomek
Laurie McComas
Leah Randall
Lesley Wheeler
Lia Cecaci
Lindsay Rolfson
Lisa Loving
Liz Dierbeck
Liz Peter
Liza Carroll
Lizzie Hudson
Luciana Faustini
Lucy Leach
Lysa Hoffman
Mailin Donahue
Mandi Barnes
Mansi Mehra
María Martín Pérez
Marta Nobre
Mary Smith

Mary Thompson
Maryam Hamzah
Maya Tomiko Kashima
Meagan Gordon
Meaghan O'Malley
Megan Morgan
Megan Southerby
Mel Sundquist
Melissa Yeo
Mesha in the dark
Micha Elizabeth
Michael Dorsey
Michael Klosowsky
Michael Mori
Michelle Cruz
Michelle Retsky
Michelle Walker
Mira Lyon
Miranda Farmer
Molly Dennert
Myra Cognet
Nancy Calvert-Warren
Nayantara Mhatre
Nichole Sutton
Nicole Bradley-Byrne
Nicole Flores
Nicole Foote
Nicole Helen Brunner
Nikki Santiago
Nitsan Machlis
Patricia Sikora
Piao Lee
Prateek Gupta
Rachel Herbert
Rachel Lin
Rachel Molnar
Rachel Teichman
Rachelle Beckerman
Rebecca Androwski
Renata Ramasra
Rhiannon Inners

Rose Jacobs
Roseanne Overton
Rrain Prior
Ruth Salter
Ryan Tovani
Sabrina Roussel
Samiha N
Sandra Down
Sara Neppl
Sara Wong
Sarah Michaud
Sarah Moum
Sarah Rosenberg
Sheena Brobbey
Sheilla May Cervantes
Stefanie Beck
Stephanie Koehler
Suzy Lafontaine
Suzzie Wilson
Sydney Cash
Syeira Budd
Tazmin Godamunne
Teresa Vice
Tharu
Theresa-Lee Palega
Thomas Wong
Tiara Webster
Tim Estrivo
Tor Weeks
Usha Gattappa
Veronica Chew
Vikram Phukan
Whitney Brooks
Yoko Sakao Ohama
Zack Kitzmiller

ACKNOWLEDGMENTS

A sincere thank you to…

FAMILY
My brother Julian, whose creative and unique post office tactics inspired me to fall even more in love with snail mail. My sister Megan, for her invaluable advisement during the publishing and design process. My parents and younger brother Elliot, for their support and tolerance of my absorption with the project. Eugene and Pam, for their support, encouragement, and hospitality.

FRIENDS
Lucy Tan, Terry Farris, and Chris Boyce, for their help planning and strategizing as the project transitioned to book form. My mentor and friend, Luis Peña, for encouraging me to follow my dreams. Ephstathia Bonadies and Jeff Greenspan for helping me with my writing. Kat Young and Katherine Fracchia, my longest running snail mail pen pals. The following people, for their support: Libby Murphy, Scott Blew, Dan Maxwell, Blaine Vossler, Mackenzie Edgerton, Julia Perriello, Andy Dao, Matt Wyne, Jeff Lam, Ji Lee, Tim Belonax, Chris Woodhead, Chris Baker, Jonathan Matas. In memory of Lillian Ben-Zion, who I corresponded with via handwritten letter.

SUPPORT
My teachers and mentors past and present, for their support and encouragement. My therapists, past and present, who inspire me to live a more balanced, deliberate life.

BOOK TEAM
My literary agent, Kate McKean, for helping shop the project and then handling my endless questions and concerns. All of the folks at Sourcebooks, including my editor, Peter Lynch, who believed in the project and put up with an overly opinionated author. Also, Tina Silva, Michelle Lecuyer, Jodi Welter, Melanie Jackson, and Katie Casper at Sourcebooks.

TRANSLATION
Jonathan De Souza, Tom Lejeune, Claire Beydon, Sabine Heymer, Carlos Alexandre Diniz, Sarah Koznek, Monivette Cordeiro, Jireh Lee Silva, Ewcia Tomczyk, Zdenek Polak, Quang Dao, Divina Trisha Parungao, Julia da Rosa Simoes, Ivonne Portas, Sydney Cash

PROJECT DONORS
Luis Peña, Steve Kohn, Julian Cash, Sherri Levy, Mat Henshall, Virginia Mcmillan, Kathryn Kelly, Lisa Jeffery, Erin Schneiderman, Mohammed Jaffry Deen Jala, Eric J Luling, Daniel Fryer, Don Coleman, Antone Gabriel IV, Sm Noctor, Kris Peleman, ия Тесцова, Pia Kinchin, John Boutwell, Cynthia Augustine, Laura A Hills, Lincoln Young, Andrew Breza, Kristin Huben, Dmitriy Skougarevsky, Chris and Melissa Woodhead, Jeff Deibel, Bláthnaid Conroy, Jasa Furlan, Lauren Smith, Abby Shure, 16 Sparrows, Karen Sullivan, Matt Marrocco, Christopher Green, Mark Gale, Alexander Tikhonov, Shannon Austin, Caitlin Cribb, Chin Lok Tsang, Steeve Patout, Rachel Gray, Yves Schelpe, Franco Acchiardo, Renee Schaefer, Morri Young, Fernando Lopez Soler, Katherine Bryden, Stephen Gardner, Graham Pope, Nathan Felt, Jonathan Moisan, Gene Park, John Quirke, Michele Lomas, Margaret Cohen, Rekha Murthy, Charlie Altman, UCC, Christy Kintzel, Clayton Pinkney, Aleza Guiriba, Shelly Wolff, Hinrich Riedel, Robert Somorai, Sheila Simon, Benjamin Rollinger, Jenna Cain, Shelley Duval, Kathleen Mulcahy, Derek Chamorro, Christine Fullgraf, Claire Snyder, Kathleen O'neill, Don Olney, Dushyanth Inguva, Frank Weber, Kathi Ganz, Ecosuisse.Ch, Daniel Tubbs, Susan Butler, Kelly Thompson, Nicholas Kang, Eric Jefferson, Kenneth Ogilvie, Alison Anderson, Jessica Manske, Matthew Vanderbrook, Mary E Voss, Naushad Kollikkathara, Maira Rahme, Christine Lorenz, Robert Butler, Margaret Corboy, Cat Sacdalan

Apologies to anyone inadvertently omitted to whom acknowledgment is due.